SCULPTING IN BU

SCULPTING
IN
BURLAP

Margaret
Hutchings

Taplinger Publishing Company
New York

To Erica, who became the daughter we had always wanted when she married our son and who, because she so generously shares her adorable family with us, gave me the fun of recording in Chapter 5 some of the simple things that we all enjoy doing together.

First published in the United States in 1975 by
TAPLINGER PUBLISHING CO., INC.
New York, New York

Library of Congress Catalog Card Number: 74-19853
ISBN 0-8008-7011-5

CONTENTS

FOREWORD

During my career as a craft teacher I have valued not only the friendship of Margaret Hutchings, but also the practical help so generously given and available to us all through her many delightful books.

When shown the collection of figures created for this book I was astounded by the sensitivity and beauty of the models, as well as by the originality shown in the use of the simple fabric and the lack of adornment.

The practical information given will enable us all to enjoy making the figures shown and will surely inspire many to create further characters in this limitless field.

My particular pleasure will come from sharing with my students yet another creative experience given to us by this exceptionally talented and able author.

<div align="right">

Monica M. Hodgson
Head of Textile/Craft Department
Brentwood College of Education

</div>

AUTHOR'S NOTE

This book is a suggestion! It is in no sense meant to be a treatise or a textbook on modelling these small, timeless, faceless figures, but is offered with a certain sense of excitement to all those who, like myself, derive pleasure and fulfilment from experimenting with a new material.

It has but one aim and that concerns adventure. By presenting photographs of some of my own experiments, giving precise instructions for making the basic figures, animals and most of their accessories, and then leaving each worker to wander through the pages, building and formulating her own ideas, mingling parts of one character with those of another, I hope to have opened fresh outlets and vistas to all who enjoy plain, strong sewing combined with inventiveness.

Just one word of warning—these figures are natural, not only in the way they take shape almost of their own accord, but also in the materials from which they are fashioned. A stone, a brick, a piece of wood, some fir cones or a few flowers will often add to their charm, but gaudy colours or modern man-made accessories will 'kill' them as surely as though they had never existed.

<div align="right">

Margaret Hutchings
South Weald
January, 1975

</div>

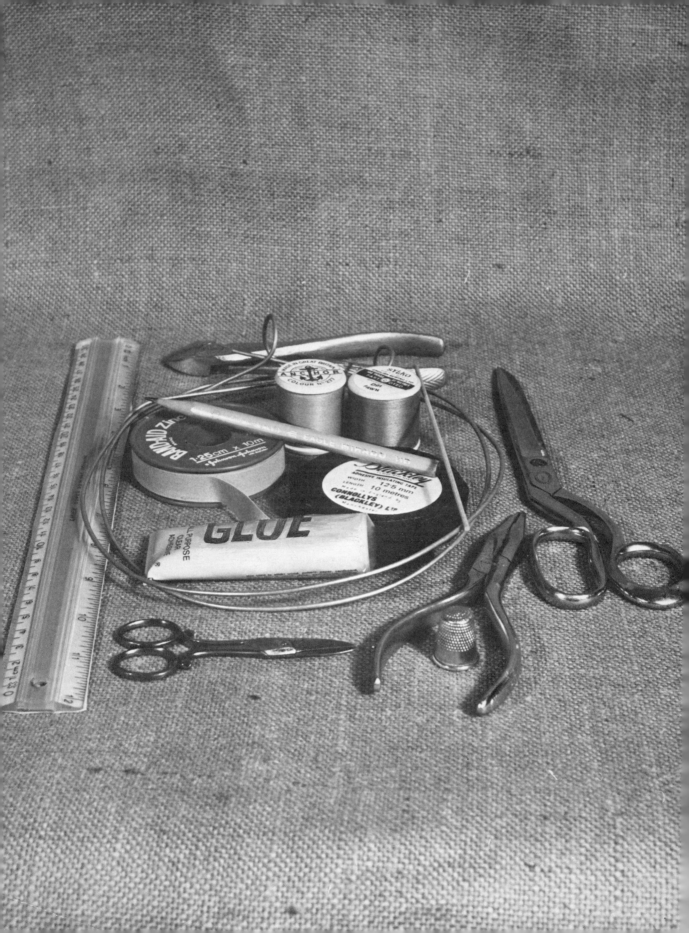

1 GENERAL INSTRUCTIONS

THE MATERIAL

Sacking? Hessian? Burlap?

Were it not that most modern sacks are made of plastic or strong paper we should probably call the material from which these figures are made sacking.

Today such material, although rarely used for sacks, is much in demand for embroidery, soft furnishings, wall coverings and display work. It comes not only in its characteristic natural colour, but in many vivid, glowing shades. In England it is called hessian and in the United States it is commonly known as burlap.

A glance in *The Shorter Oxford English Dictionary* tells us that:

sacking is a coarse woven material of flax, jute, hemp, etc., used
 chiefly in the making of sacks and bags;
hessian is a strong, coarse cloth used for packing bales;
burlap is a coarse canvas made of jute and hemp used for bagging.

Thus, in the words of my wise old grandmother, all three are 'the same thing only different.'

A glance at the photographs will, I feel, show would-be workers exactly what is needed. In order to avoid confusion and because I hope this little book will find a home in many parts of the world, I have referred to sacking? hessian? burlap? simply as *the material* throughout the pages that follow.

The material is usually 1 yard (1 metre) wide and is obtainable from most drapers, upholsterers or department stores. In case of difficulty write to:

> The Hessian Shop,
> 32 Greville Street,
> London EC1

Use only the plain, natural colour, like that of an old-fashioned sack. The charm of the figures lies in their crude simplicity, which is immediately lost if colours are introduced.

As it is presupposed that most workers will make more than one figure no material quantities are given for individual characters. Therefore, because the material is comparatively inexpensive it is a good idea to buy 1 yard (1 metre) to start with. This quantity will go a long way and make many figures.

The material works best if soaked overnight in hot water (in the kitchen sink or the bath), then drip dried and carefully pressed while still slightly damp.

Exposure to prolonged, strong sunlight alters the colour of the material to a slight extent. It is important, therefore, to watch where you stand the finished figures. If they are in a sunny position, turn them from time to time to avoid rather unpleasant faded patches spoiling their appearance.

THE TOOLS AND OTHER NECESSITIES

A ruler or tape measure, large scissors for cutting out and a small pair for cutting threads and snipping odds and ends, a dark pencil for marking the material, a thimble and a small piece of wood or fine skewer for use as a stuffing stick.

Strong button thread and mercerized cotton thread (such as Sylko in Britain, and Coats & Clarks in the United States) that exactly match the material, the button thread for most of the hand sewing and the cotton thread for machine stitching, and suitable needles for use with both.

Galvanised wire (for details see page 13), pliers for both cutting and bending the wire and strong $\frac{1}{2}$ inch (1.3 cm) wide adhesive tape (either the medical or electrical variety) for binding it.

A tube of strong, colourless adhesive for attaching hair, turning back hems, shaping and setting beards and many other small jobs.

CUTTING AND STITCHING

Unless otherwise stated always cut out all parts with the material on the bias. This allows the threads to stretch and gives shape and character to the finished work.

It is a good idea to machine all round the outside edge of all pieces as soon as they are cut out and before starting work, as this prevents fraying.

Before machining parts together pin them carefully to avoid slipping, then stitch twice—there and back again.

When turning narrow tubular parts, such as sleeves or trousers, a pair of pliers is a great help in grasping a fold of the material and pulling it through.

When turning back raw edges of sleeves, aprons, etc., use either an invisible slip stitch with thread that exactly matches the material, or a scant smear of adhesive. Always turn back just a *single* fold, leaving the raw edge exposed on the wrong side of work.

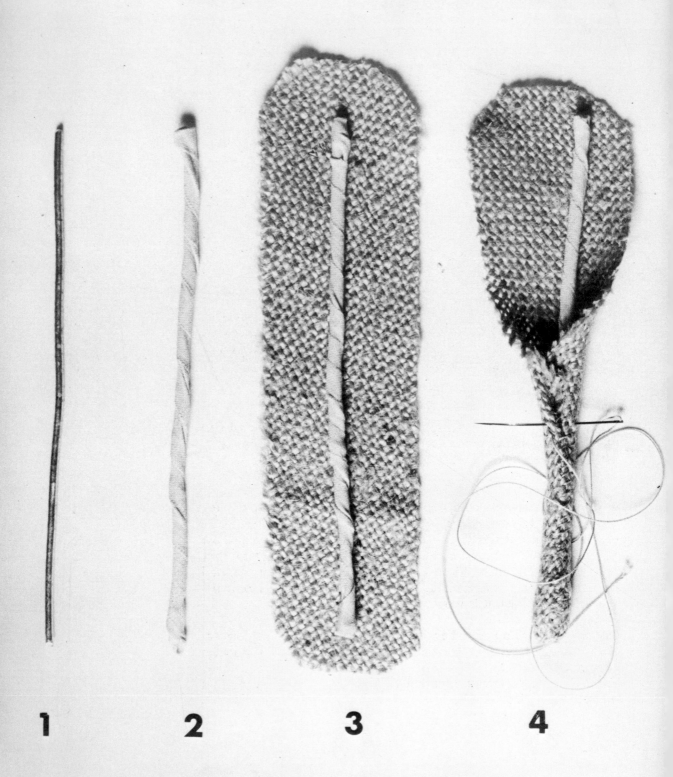

Preparing and covering wires

PREPARING AND COVERING WIRES

All the figures and animals are supported by wire frames. If making a quantity of characters it is worth buying a coil of galvanised wire from an ironmonger or hardware store. Take your knitting needle gauge with you and choose wire that corresponds to a size 12 knitting needle (American size 1). This will give adequate support, but is not too stiff to bend and adjust with pliers. The wire should be prepared and covered in the following way:

1 Cut off the required length.

2 Bind it tightly with $\frac{1}{2}$ inch (1.3 cm) wide adhesive tape—either medical or electrical insulating tape will do. Make sure you cover the sharp ends.

3 Cut a strip of material on the bias, $1\frac{1}{4}$ inches (3 cm) wide and just a little longer than the wire. Snip off the corners.

4 Fold and roll the raw edges of material inwards, and oversew firmly in place so that the wire is completely covered. Make sure that you fold the short ends of material over at the beginning and before you finish. Covering the wire increases its length, owing to the thickness of the adhesive tape and material.

STUFFING

There is no need to buy any special stuffing, although if you wish to use kapok, a soft resilient natural material, it is ideal. Very small quantities are needed, as only the heads of the figures and the bodies of the animals are filled.

All the originals were stuffed with the cuttings and snippings left over from making them; a little pile is shown on page 39. Small pieces of material should be literally torn to shreds by pulling the threads apart. The threads should be snipped into short pieces if they are more than an inch (2.5 cm) long or they will not fill out the odd nooks and corners successfully. (Never use cut up material, only the threads from which it is woven.)

It is a good idea to keep a bag full of prepared shreds so that they are ready when needed. When stuffing, use a fine piece of wood, a skewer or your finger to pack the material into the parts and shape them. The finished work should be of rock-like firmness, so full that you cannot pack in another shred.

MAKING BASIC ADULT FIGURES

The average height of these figures is 8 inches (20.5 cm).

Stage 1 Cut two pieces of wire 4¾ inches (12 cm) long and two pieces 8 inches (20 cm) long. Prepare and cover these as explained and illustrated on pages 12–13. The two short pieces are for supports and will be entirely invisible under the skirt of the finished figure. Stitch these together very firmly at the top, working downwards for about ¾ inch (2 cm).

Stage 2 Take one of the long pieces and at one end bend about 1 inch (2.5 cm) forward to make the foot. Stitch the joined support pieces firmly to this long piece, working several times up and down for about 1 inch (2.5 cm). Bend and adjust these three wires so that they stand very firmly, forming a kind of tripod.

Cut a cardboard template of the head (pattern, page 108). Place this piece on the doubled material (remembering to have the weave running on the bias) and pencil all round the edge. Remove the template and pin the two thicknesses of material together in one or two places. Machine-stitch them together on the pencil line from A round to B. Then stitch back from B to A, working a fraction outside the first row of stitching. Cut out the head leaving a very small turning outside machine-stitching, but leaving about ½ inch (1.3 cm) outside the pencil mark B–C.

Stage 3 Remove the pins and turn the head right side out, easing and pressing the seams well out with the help of the blunt end of a pencil or smooth piece of wood. Stuff the head very firmly and carefully, packing it really tight and shaping by pushing out chin and cheeks with a small stuffing stick. Because the material is on the bias it will stretch and shape easily. Take the prepared wire foundation and push the neck end just up into the stuffed head. Make sure the centre front seam of head runs down centre leg and foot wire; pin it in this position. Turn and fold the back edges of the neck inwards and oversew them tightly together B–C. The neck should be stretched firmly around the wire support. The ultimate height of each figure can be adjusted at this stage by pushing the neck wire further into the head. Thus groups can contain figures of varying heights.

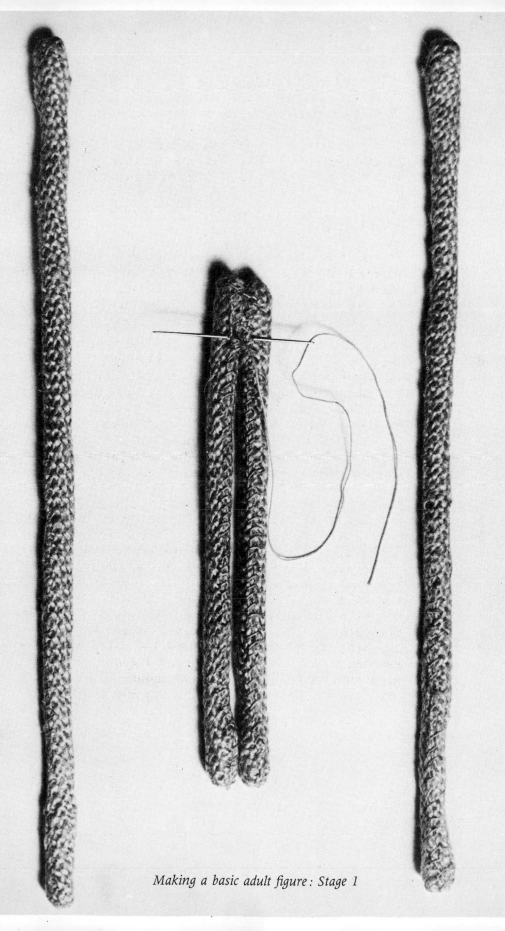

Making a basic adult figure: Stage 1

15

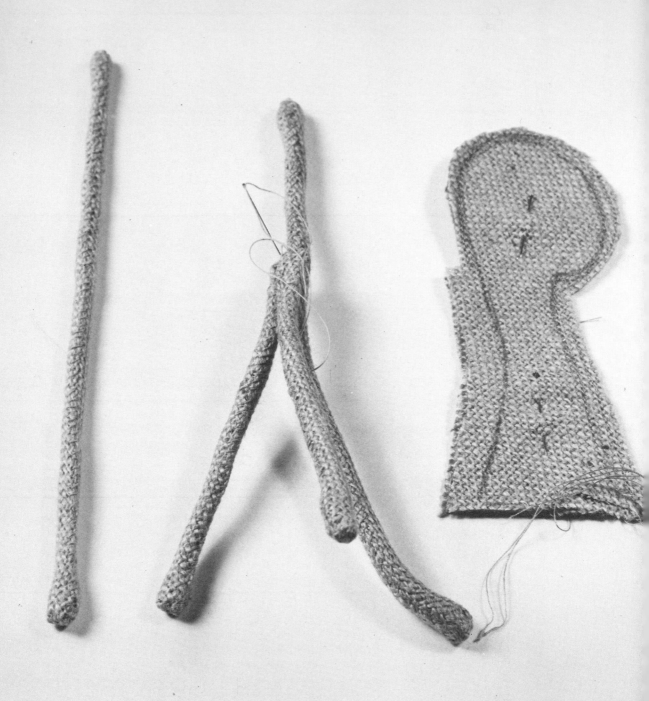

Stage 2

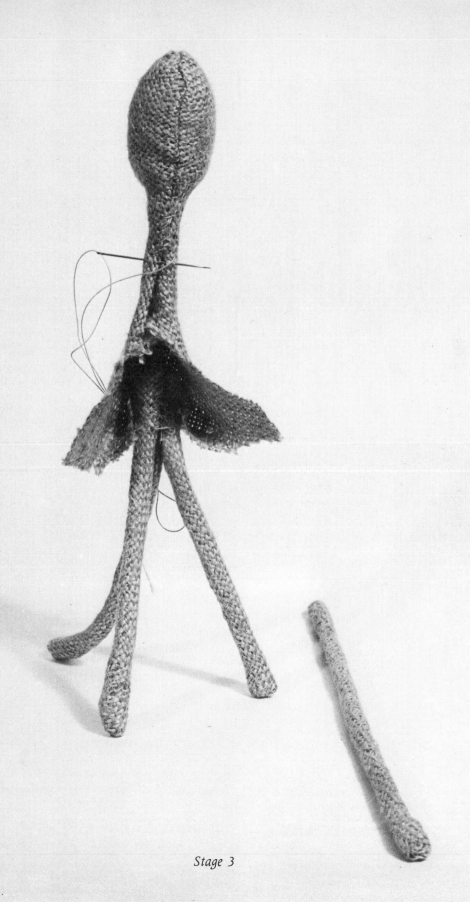

Stage 3

Stage 4 When you get towards the end of this seam, turn the lower edge (C–A–C) of the head piece inside, losing about ½ inch (1.3 cm). Stitch all round this lower edge, attaching it firmly to all three wire supports.

Measure the prepared arm wire to find the exact centre. Mark this point with a pin. Pin the wire to the back of figure approximately ¾ inch (2 cm) down from head and stitch firmly in this position. Remove all pins and adjust figure to stand firmly. Cut two pieces of bias material 3 × 5 inches (7.5 × 12.5 cm) for the sleeves. Fold these in half lengthwise, and machine-stitch about ¼ inch (.6 cm) from the edge to form a tube. Machine again a fraction outside the first row of stitching. Tie off ends of thread. Turn back approximately ¾ inch (2 cm) at one end of each sleeve and secure with a scant smear of adhesive or by slip stitching. This is to neaten the sleeves at wrist end. Turn both sleeves right side out.

Stage 5 Slip each sleeve over an arm wire, seams downwards, and pin at wrist, leaving the ends of arms showing for hands. Tuck in the other ends of sleeves and pin so that the body shows in the centre at the front, but not at the back. Ladder stitch neatly all round this end of both sleeves so that they are firmly attached to the body. The wrist ends of the sleeves may either be left loose (see page 50), or gathered round the edge, pulled up to fit arm and firmly stitched in place (see page 48).

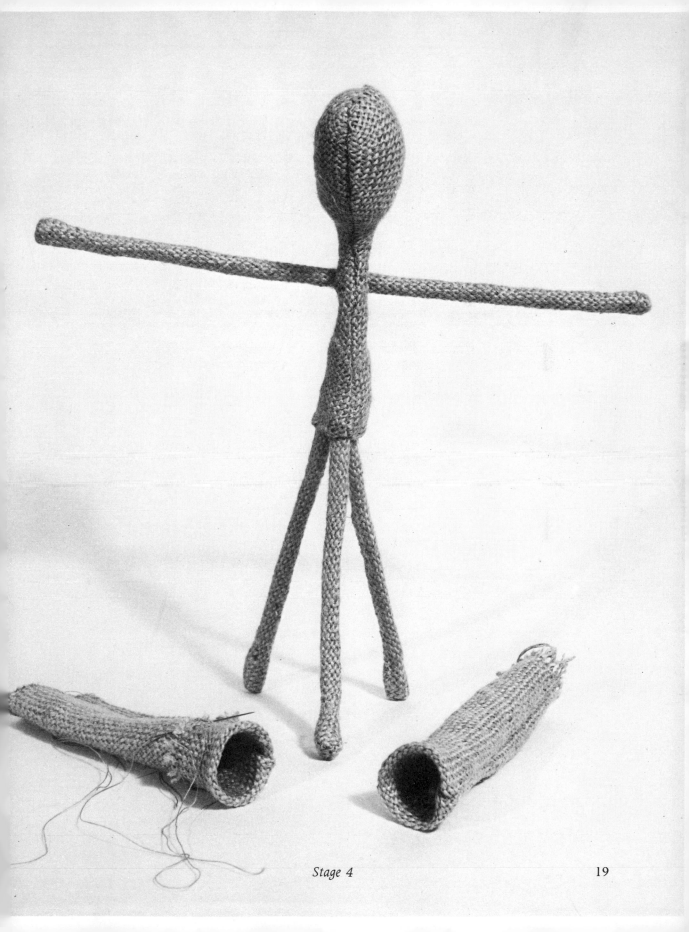

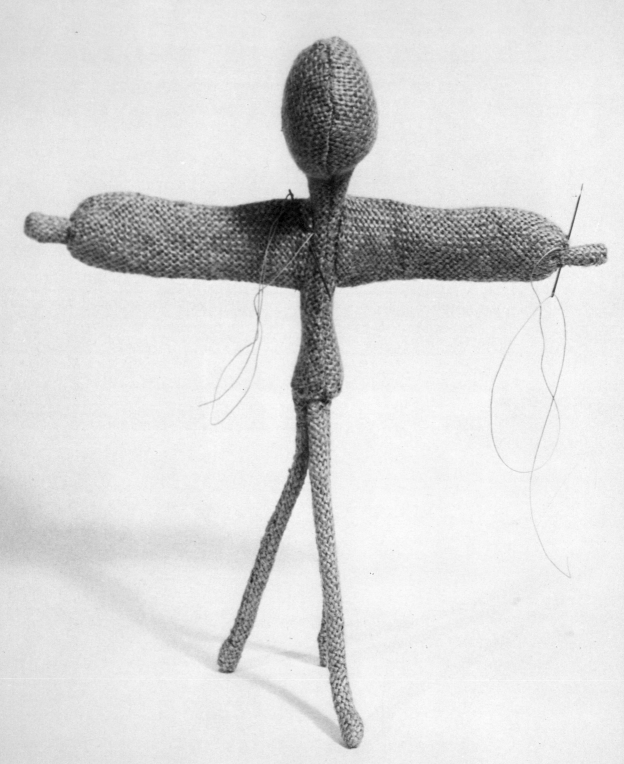

Stage 5 : front view

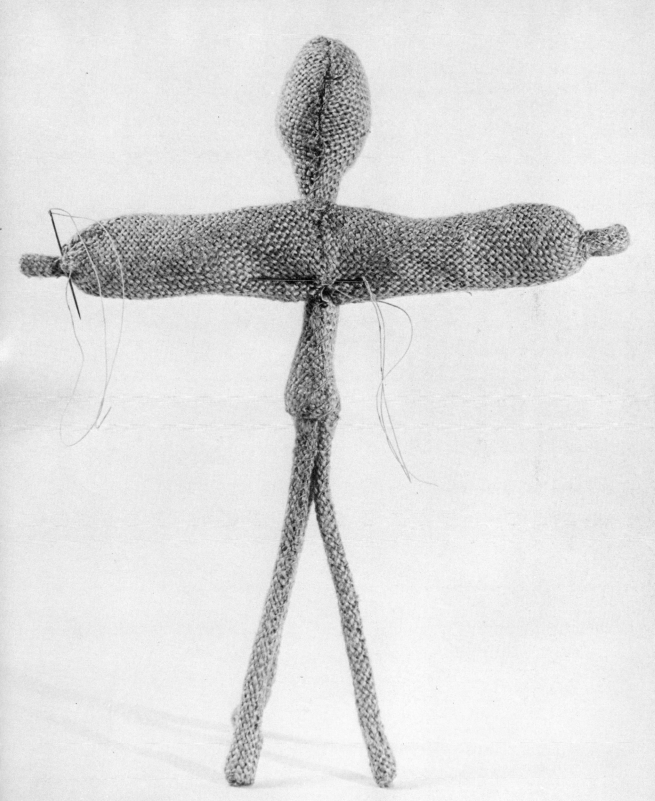

Stage 5: back view

Stage 6 Cut a piece of material on the bias 12 × 8 inches (30.5 × 20.5 cm) for the skirt. Machine the short ends together to make a ring, taking about $\frac{1}{4}$ inch (.6 cm) turning. Machine across the same seam again a fraction outside the first row of stitching. Turn right side out. Turn about $\frac{1}{4}$ inch (.6 cm) inside all round one edge. Gather all round this edge working through both thicknesses of material. Put skirt on figure, pulling up gathers as tightly as possible and pinning in place with seam on skirt at centre back of figure and the gathers divided evenly all round body. Stitch skirt firmly to figure, working several times all round. The skirt is now much too long of course.

Stage 7 The superfluous length on the skirt is used to form a base and must be carefully stitched so that the figure stands very firmly. This can be achieved in one of two ways; use whichever method suits your character best.

A Cut a small hole in the skirt for the figure's foot to show through. Turn the raw edges in and neatly and firmly stitch all round the hole, attaching the skirt to the foot. Then gather all round the lower edge of skirt, taking a small turning as you work. Pull up the gathers as tightly as possible and fasten off neatly.

B Turning in the lower edge of skirt, pull the centre front tightly round 'ankle' and stitch in place. Fold and stitch the remaining material as shown.

In both cases adjust the figure for firm standing, then add the hair (see page 26).

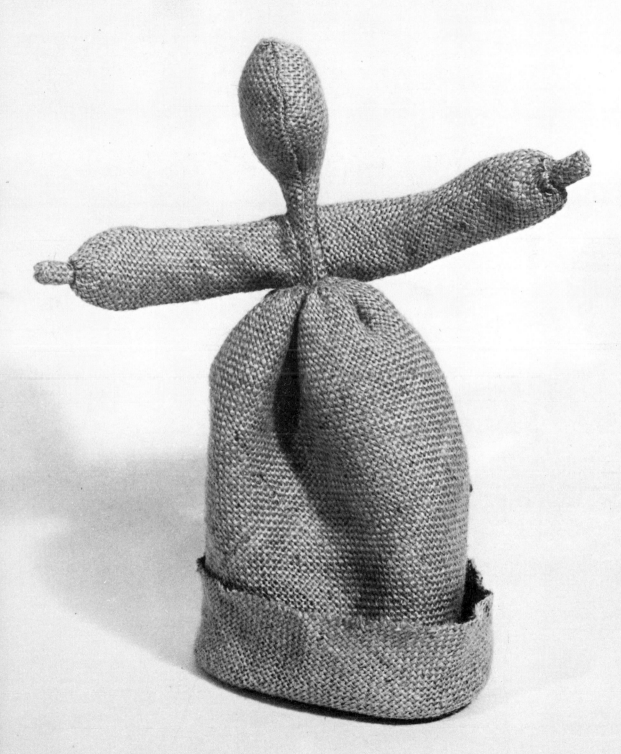

Stage 6 : front view

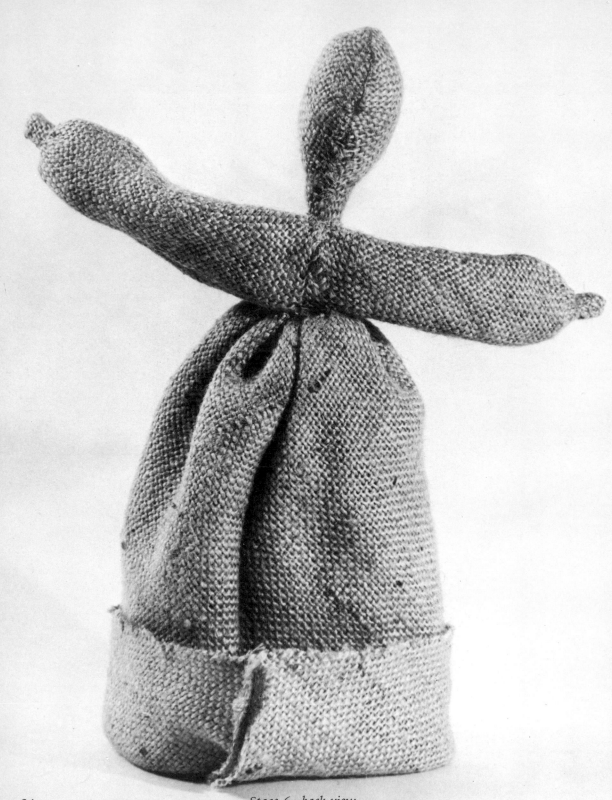

Stage 6 : back view

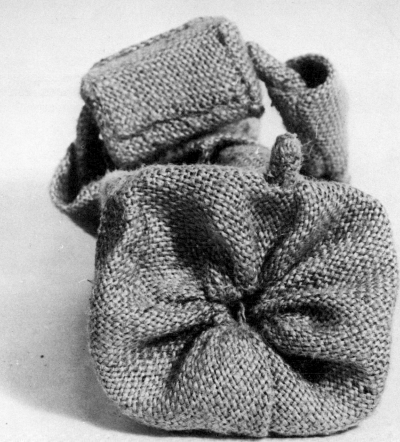

Stage 7 : method A

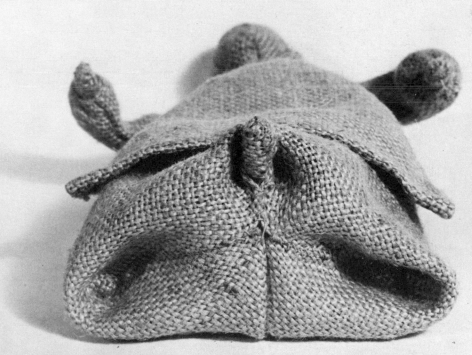

Stage 7 : method B

MAKING AND STYLING LONG HAIR

Long hair is the most effective for adult figures, except for special characters such as the witch (page 66) and some Christmas figures (pages 96–107), which will be discussed separately.

Long threads should be pulled from odd pieces of the material; they should be *really* long to allow for ease of manipulation when styling. Threads that reach to the floor on either side of the figure—i.e., up to 18 inches (46 cm) long—are a special help if plaited coronets, buns, or earphones are to be made, for a surprising length is needed to achieve the desired effect. Any superfluous length can be trimmed off after styling. It will not be wasted, as it can be cut up and used for stuffing (see page 13). The most important thing to remember is not to use *too many* threads or the finished style will be bulky and out of proportion.

Spread adhesive thinly over the scalp, about $\frac{1}{2}$ inch (1.3 cm) each side of the centre seam on head. Lay the threads carefully and evenly across the head, pressing them well down on the adhesive (see pages 27 and 28). Take particular care over the back (page 28).

Using strong thread and a long needle, take two or three long stitches from centre front over head to where hair divides at the back (see pages 30 and 31); this makes a centre parting. (A side parting could be made, of course, if preferred.) Spread a little more adhesive on back of head between end of parting and neck. Smooth the back hair neatly downwards over this, pressing it to the head. Now decide on a style. If long loose hair is required, like that of the goose girl (page 76), Mary (page 101) or the angel (page 106), it should merely be trimmed to the desired length.

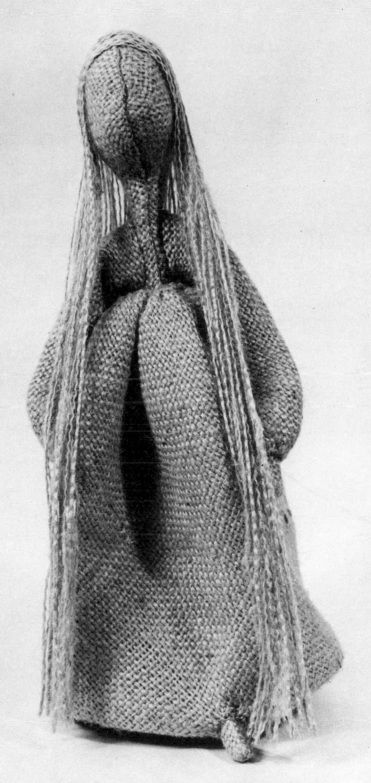

Sticking long hair to scalp: front view

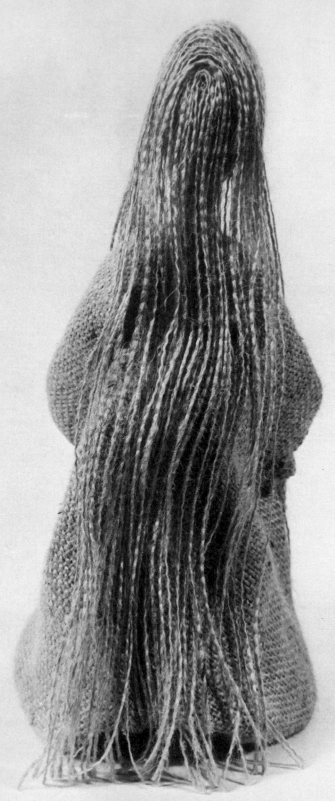

Sticking long hair to scalp: back view

To make a style that involves two plaits, divide the threads neatly at nape of neck and stitch firmly in place at each side (page 30). Plait the threads tightly, then bind or stitch with matching thread to secure the ends (page 31). Trim off surplus hair and put on one side to use as stuffing. The pigtail shown on page 31 consists of hair that reached to the ground before plaiting. It clearly illustrates the necessity of starting with threads that are much too long for the finished purpose.

Now arrange and style the hair as you wish. A glance through the book will give you many ideas. Plaits may be left hanging loose at the front or the back, or twisted into coronets, buns or earphones and stitched firmly in place, always tucking the cut ends in well out of sight. If a single pigtail is preferred, the threads should be drawn back and stitched or stuck at the nape of the neck before plaiting, instead of being divided as shown on page 30 for two pigtails. A single braid pulled forwards over the shoulder, as for the shepherdess on page 68, is very effective. It was also used for making the bun for the wood gatherer on page 88.

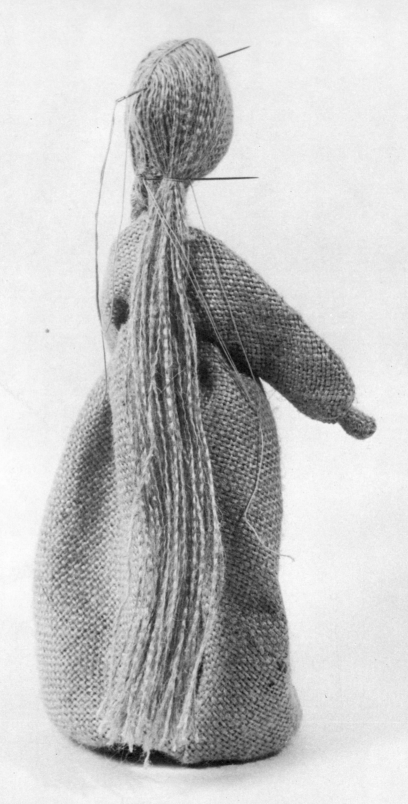

Making a centre parting and dividing hair for two pigtails

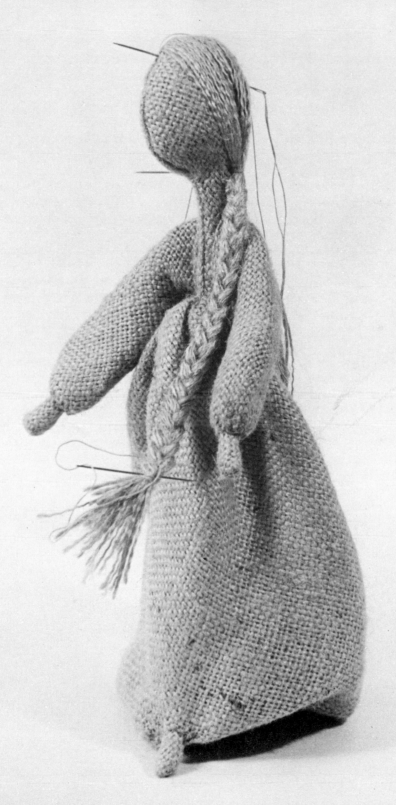

Making a centre parting (front view) and finishing off end of pigtail 31

A ponytail, in which the hair has the appearance of being drawn up to the top of the head, with no parting (page 93), is made by a completely different method. Pencil a hairline all round the bald head of the figure, first considering very carefully just where you want it to be. It is a help to pull your own hair upwards and note how it grows, for example, well down in the nape of the neck. Then cut a piece of material wide enough to form the length of the hair—approximately 6 inches (15 cm)—and with a selvedge long enough to stretch twice round the pencil hairline—approximately 10 inches (26 cm).

Draw out all the long threads, leaving only the selvedge and the two threads next to it. The discarded threads should be tied in a bundle and put aside for making short hair styles, such as those on the witch and some of the children.

You are now left with a length of fringe. Starting at centre back, pin this once round the bald head of figure, placing the selvedge on pencil line and having the loose threads hanging down all round. Stitch firmly in place just below the pencil line, so that it is hidden, working through the second long thread (opposite). When you have completely encircled the head, remove the pins and carry on using up the entire length of fringe by stitching a second circle in place a fraction above the first, so that there are two layers of threads hanging down all round figure. These may then be drawn neatly and tightly upwards to top of back of head, and bound with a matching thread to form the pony tail. Arrange the tail neatly and trim ends to achieve a slightly tapered effect. Smear a little adhesive among the threads and press them together so that the hair stays tidily in place. (See plaiting, page 93).

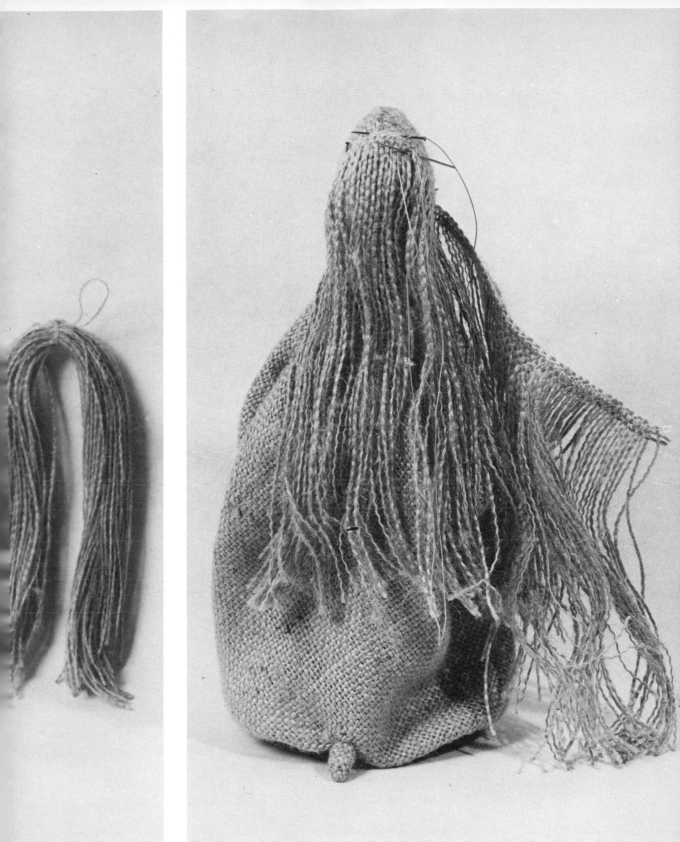

First steps in making a ponytail; discarded threads are shown bundled ready for use on child figures

MAKING BASIC CHILD FIGURES

Girls (average height 5 inches or 12.5 cm)

Stage 1 Cut two pieces of wire $3\frac{3}{4}$ inches (9.5 cm) long for legs, one piece $4\frac{3}{4}$ inches (12 cm) long for arms, and one piece $1\frac{1}{4}$ inches long (3 cm) for neck. Prepare and cover these as given on page 13. Stitch the tops of the leg pieces together very firmly for about $\frac{1}{2}$ inch. Cut out the head piece as given on page 110, and run a gathering thread all round the broken line. Pull up gathers, at the same time stuffing very firmly so that the head becomes a hard, little round ball. Finish off carefully at back, stitching across many times in all directions. Adjust the shape of head by pummelling and rolling. Stitch the neck wire very firmly to centre back of head and downwards for about $\frac{1}{2}$ inch (1.3 cm).

Stage 2 Place the lower end of neck wire directly on top of the joined leg wires exactly in the centre. Stitch them in this position by ladder stitching round several times, working backwards and forwards through the material, covering all three wires. The finished work should be very firm indeed and give the appearance of the two leg wires suddenly turning into one.

Stage 3 Find the exact centre of the arm wire and stitch it firmly in place on the back of the figure at the lower end of the neck wire.* Cut two pieces of material $2\frac{1}{2} \times 3\frac{1}{2}$ inches (6.5 × 9 cm) for the sleeves. Fold these in half lengthwise and machine-stitch about $\frac{1}{4}$ inch (.6 cm) from the edge, then stitch back again. Tie off ends. Turn back about $\frac{1}{2}$ inch (1.3 cm) at one end and secure by slip stitching or with a scant smear of adhesive to neaten wrist end of sleeve. Turn right side out.

Stage 4 Slip the sleeves on arms so that a small portion of the arm is left showing for hands. Pin at wrist, making sure the underarm seam is in the correct position. Tuck the other ends of sleeves inside and stitch the sleeves together at front and back so that the neck wire and joined top of legs is hidden. The front and back will look exactly alike. The wrist end of the sleeves may either be gathered up and stitched to the arm wires, as in the photograph on page 36, or left plain and loose, as on the girl with a ball on page 59.

Stage 5 Cut a piece of material $5\frac{1}{2} \times 7$ inches (14 × 18 cm) for skirt. Machine the short ends together to make a ring. Turn right side out. Gather all round the top, turning the raw edge inside as you work. Slip on the figure, having the skirt seam at centre back. Pull up gathers and stitch firmly in place all round waist. The skirt is now much too long. Run a gathering thread all round the lower edge, turning the raw edge inside for about $\frac{1}{2}$ inch (1.3 cm) as you work.

Making basic child figures : girls

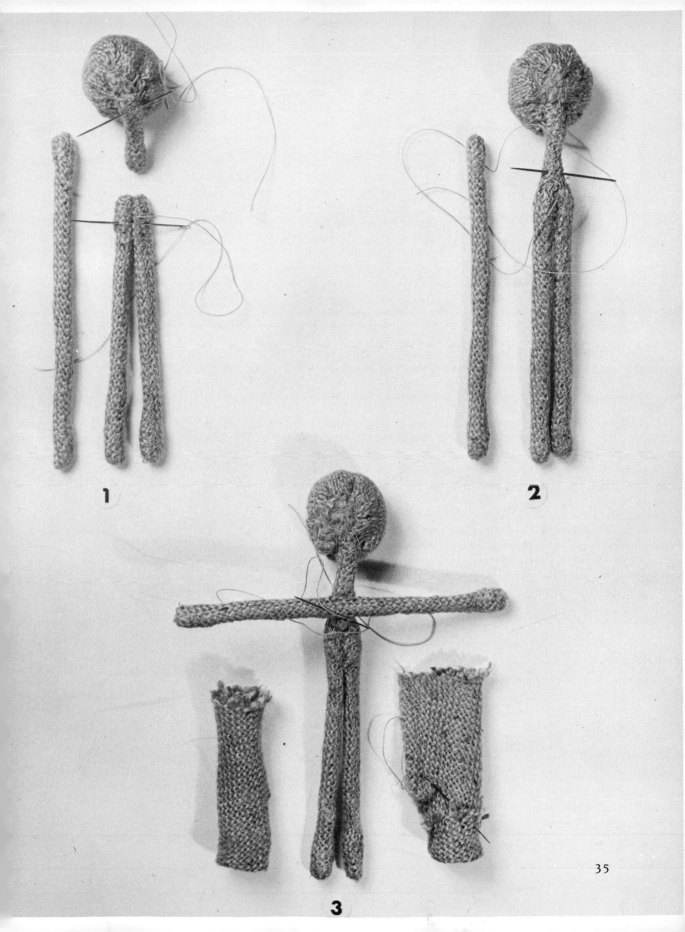

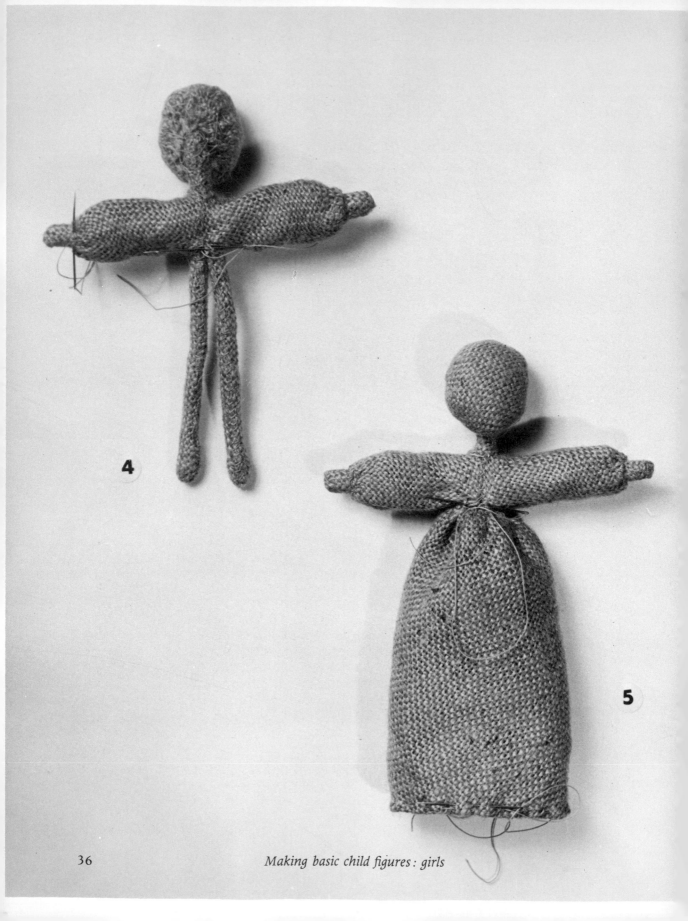

Making basic child figures: girls

Stage 6 Bend the legs apart, then pull up the gathers and fasten off, as shown for the adult figure on page 25 (top). Now adjust the figure for firm standing by pressing and arranging the base of the skirt with the pulled up gathers in the centre underneath.

These figures do not always show a foot and, as they are short, they stand very securely without a third leg support. The adults, however, need a tripod base because they are tall and would overbalance without it.

Short skirts In some instances you may prefer to dress your little girl figures in short skirts. This is only practicable if the child is being used in a group so that it can be supported by another figure, for without skirts to steady them such figures will not stand alone.

The little girl looking at the new baby on page 90 is an attractive example. Short-skirted children can, of course, be used in sitting positions, as illustrated by the girl listening to the storyteller on page 92. When making this type of child figure, cut the skirt shorter in the first place. Then, when you have gathered the top and stitched it to the figure, tuck up the lower raw edge, experimenting to find the most attractive length. Mark the lower edge with pins and stick back the hem, which should be very wide so as not to show the raw edge, using a scant smear of adhesive and pressing the two thicknesses of material well together between your thumb and forefinger. Bend about $\frac{3}{4}$ inch (2 cm) of the lower end of each leg forward for feet, using pliers. Little girls dressed in trousers are made in exactly the same way as boys.

Boys (average height 5 inches or 12.5 cm)

Stage 1 Work exactly as given for the girls Stage 1 (page 34), but do not sew the leg pieces together.

Cut two pieces of material $5 \times 2\frac{1}{2}$ inches (12.5 × 6.5 cm). Fold in half lengthwise and machine seam to form trouser legs. Turn back about $\frac{3}{4}$ inch (2 cm) at one end of each leg, securing with a little adhesive. Turn right side out. Turn lower $\frac{3}{4}$ inch (2 cm) of each leg wire forwards for feet. Slip a trouser leg on each wire, having the neatened edge at 'ankle' and the seam at centre back. Pin in this position at back of each foot. Tuck raw edge of each trouser leg inside, level with top of leg wire, gather round top, pull up and stitch firmly in place.

Stitch legs, complete with trousers, firmly together from the top downwards, working through both the trouser material and the material that covers the wires.

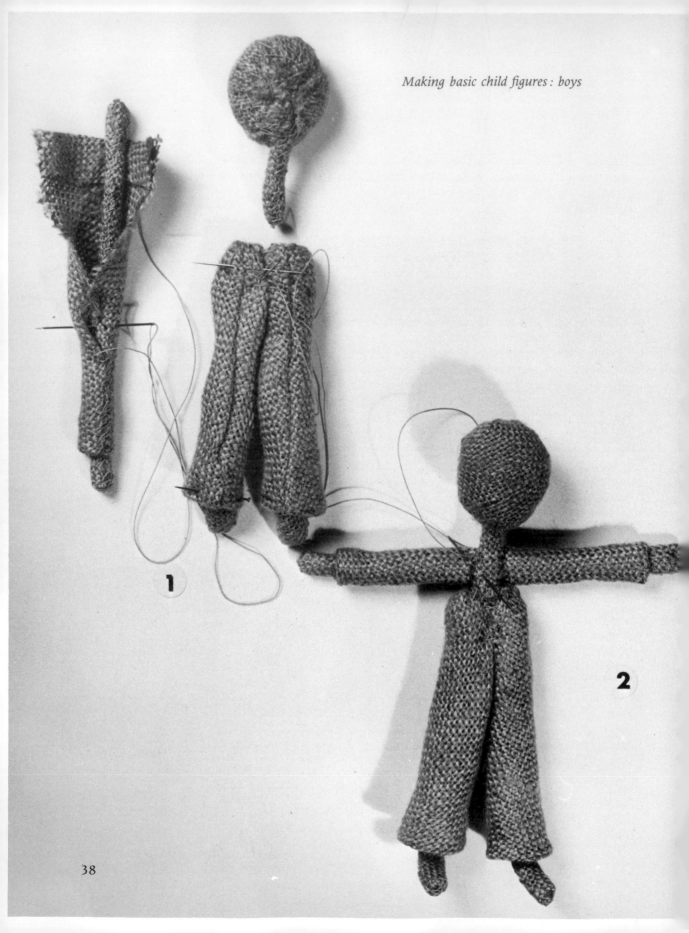

1

2

Cut a strip of material 5 × 2 inches (12.5 × 5 cm). Roll this round the arm wire so that it fits tightly. Oversew in place, tucking in the raw edges at wrists as you work and leaving a small piece of the arm protruding at each end to form the hands.

Stage 2 Work exactly as given for Stage 2 of the girls (page 34). Then work as given for Stage 3 of the girls as far as *. This figure will now be complete with trousers and sleeves.

Stage 3 Cut two pieces of material 3 × 2½ inches (7.5 × 6.5 cm). Place one at the front and one at the back of the figure, turning the raw edges in for a good ½ inch (1.3 cm). Oversew the pieces together along shoulders and down sides to make a sweater. Push a little stuffing between body wires and sweater at front and back to make the figure a good shape, then invisibly stitch lower edge of sweater to trousers all the way round. Stitch 'armholes' of sweater to sleeves, working all round.

These little boy figures will not stand alone, but, as will be seen, can be supported in a very attractive and unobtrusive way by giving them a suitable toy to hold or placing them near another figure.

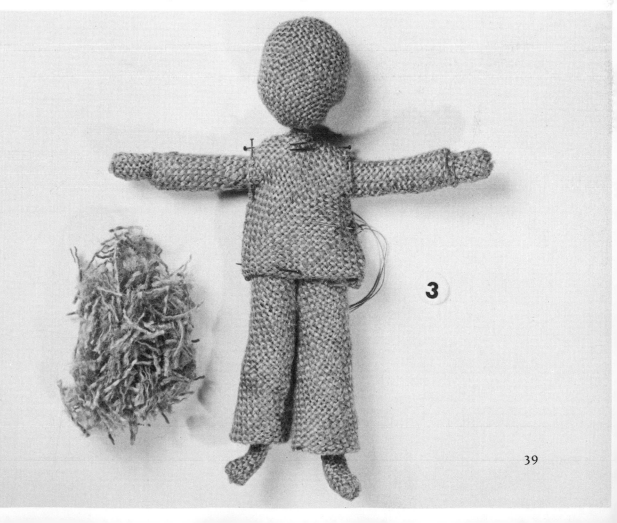

SHORT HAIR FOR THE CHILDREN

Pigtails, ponytails, etc. for the little girls can be made exactly as shown for the adult figures on pages 26–33. The boys, however, need short hair.

1 Curls

A Cover the head with a series of looped stitches using thread pulled from the material. Take particular care to get an attractive hair line at the front.

B At the back be sure to completely cover the neck wire where it joins head and to make the lower edge a good shape.

2 Straight

A Sew a fairly thick bundle of threads pulled from the material to the top of the head.

B Spread adhesive on forehead and all over back and sides of head. Carefully arrange the threads evenly all round head and press in place.

C When dry, trim threads off to shape required.

D Pay particular attention to the back so that the neck wire is well covered.

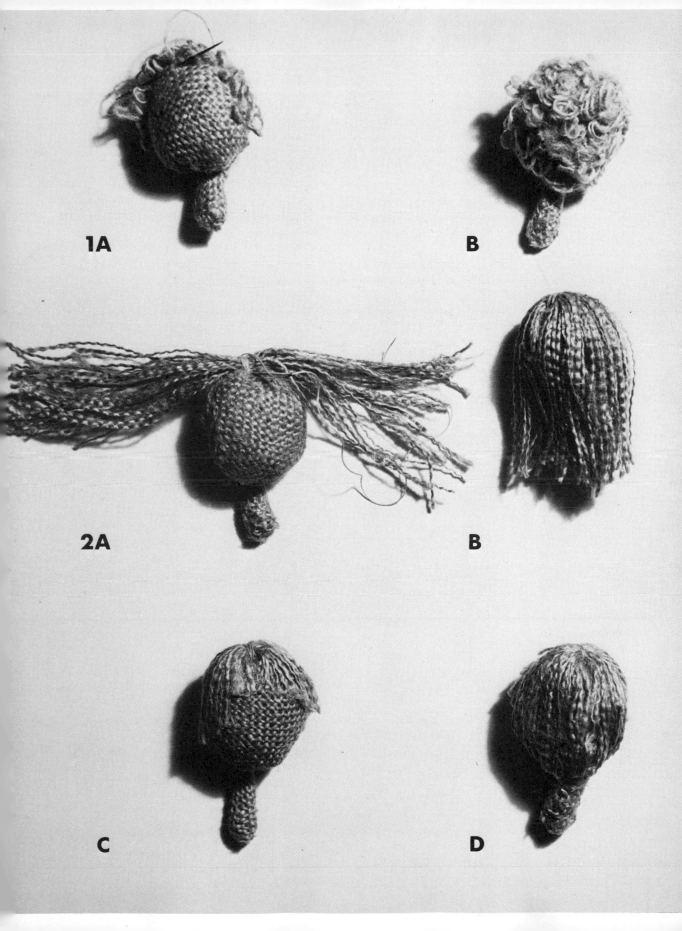

1A B

2A B

C D

APRONS AND SHAWLS

Aprons add character to some of the figures. They are merely rectangles of material with a narrow hem stuck back on three sides. The fourth side is slightly gathered to fit waist, the raw edge being turned back at the same time. Vary the length and fullness of each apron. On most of the originals the aprons were cut on the straight of the material to give contrast to the rest of the figure, which was on the bias (see pages 52 and 46). To give aprons 'movement', as shown by the girl skipping on page 64, smear the corners with adhesive and twist them slightly forward until set.

Shawls placed round the shoulders and heads are often attractive. A square is usually the best shape. The edges should be fringed by pulling out a few threads, then the shawl folded in half diagonally and stitched in place; see the flower seller on page 44, and the old woman with cat on page 81. Knitted shawls are described below.

A wide collar consisting of two triangles meeting at the back makes a change from a shawl and completely changes the appearance of the figure (see page 47 and the colour plate facing page 48).

KNITTING

A small piece of simple knitting gives an interesting texture to certain characters. It should, however, be used sparingly and with discrimination. A diamond-shaped shawl folded in half lengthwise and placed round the shoulders of the storyteller on page 92 gives the impression of someone sitting out of doors on a slightly chilly summer day. The same shape pulled tightly round the head of the holly gatherer on page 52 makes her look warmly wrapped against cold winter winds.

Rolled up and stitched into the crook of the mother's arm, the shawl gives an illusion of a new baby on page 90.

Threads pulled out of any oddments of material left over from making the figures can be knotted together, wound into a ball and used as knitting yarn. Make sure the knotted ends all come on one side of the work by pushing them through from one side to the other with the point of your knitting needle. The knotted side will be invisible if placed next to the figure when the knitting is stitched in place. The finished article gets no wear and tear, so a little 'cheating' like this will not weaken the work.

Alternatively, if you have a piece of material that runs its full original width, you will find that a thread will pull backwards and forwards

very easily. Just start to knit using the end of the weft, having the material in a pile on the floor beside you. Pull the thread gently as you need it; there is no need to wind it into a ball.

Always work in garter stitch (plain knitting)—fancy patterns are not nearly as effective—using size 12 needles (American size 1).

To make the shawl

Cast on 2 stitches.

Increase one stitch at the beginning of every row until there are 30 stitches on the needle.

Knit 2 rows.

Decrease one stitch at the beginning of every row until all stitches are worked off.

Run in ends of thread and cut off.

To make a knitted shawl with a fringed edge, like the one worn by the old woman on the colour plate facing page 65, make an ordinary material shawl and fringe the edges. Line the knitting with this, and stitch the two together all round the edge, allowing the fringe to show.

Small squares of knitting can be used to make sweaters for some of the little boy figures. See *Shopping with Granny* on page 94, where the knitting is used sideways. The best way to make these sweaters is in four pieces. Cast on 10 stitches for each piece. Knit until the pieces are large enough to stitch round each arm for sleeves, and across the front and back of figure for the main part. Cast off and stitch the pieces to the figure.

Too much knitting will spoil and detract from a figure's main characteristics. Therefore:

Use it only for a figure on which all other parts are plain so that the texture stands out in strong contrast. For the same reason hair styles of these characters should be severe, straight and smooth; a curly head will spoil the effect of the soft, woolly knitting.

If making groups, add knitting to only *one* of the figures, or the overall appearance will be muddled.

Never use knitting on a figure accompanied by curly sheep. The effect of one kills the other, the sheep only standing out with a woolly appearance if accompanied by a very plain figure.

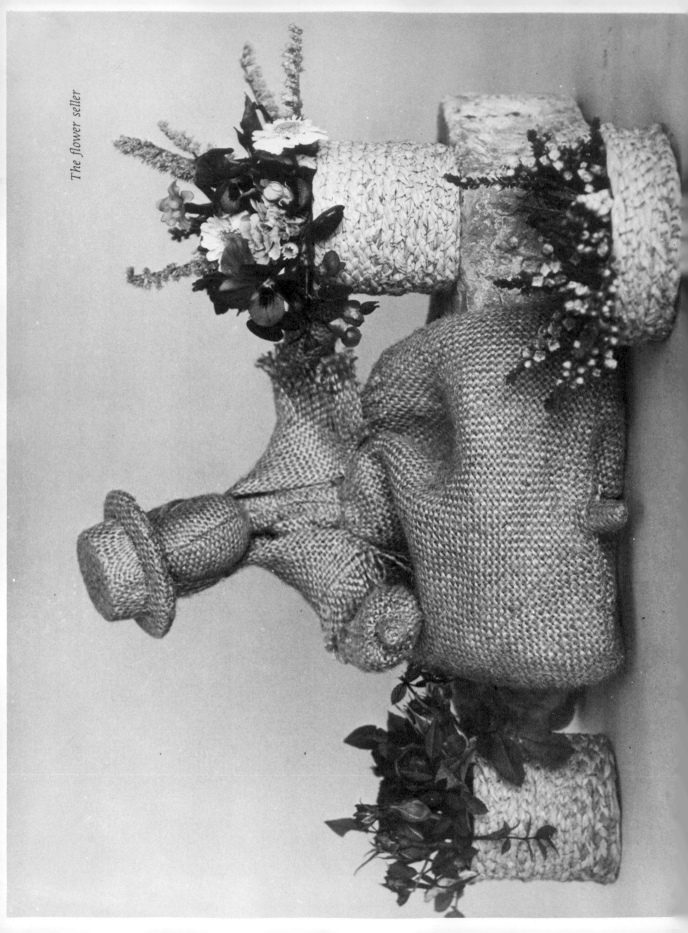

The flower seller

2 FIGURES USED AS CONTAINERS

Much interest is added to a figure by the addition of a basket. Ideas for their use in this way are illustrated on the next few pages, and instructions for making the baskets are given.

The flower seller opposite sits on an old brick, which seems to suit her ideally. Her hat brim is a circle of stiff cardboard 2 inches in diameter (5 cm). Cover it with material by cutting two slightly larger circles, then oversew them together all round the edge of the card, tucking in the raw edges at the same time. The crown is a screw top from a bottle. It is 1 inch in diameter (2.5 cm) and covered with material. Cut a large circle, gather round the edge, place the cap in the centre, top downwards, and pull up the gathers on the hollow side. The crown is first stuck, then ladder stitched, to the centre of the brim. The hat is completely flat underneath and is merely stuck firmly to the top of the flower seller's head. The original had her hair twisted into a bun at the back.

The Dutch girl on page 46 carries sugared almonds, which look like large goose eggs. The fact that she is meant to be Dutch is suggested by her clog and cap.

The clog is merely two small triangles of material stitched together. Turn right side out, slip over the protruding foot and stitch in place, tucking in the raw edges at the same time. Smear the clog with adhesive and press upwards, shaping from time to time until firmly set.

To make the bonnet, trace the pattern on page 109 and make a cardboard template. Draw all round this on a double thickness of material. Machine all round the pencil line A–B–C–B–A and back again. Cut out, leaving a small turning. Turn inside out, then neatly oversew A–D–A, turning in raw edges as you work. Press flat. Fold cap in half and oversew back seam A–D. Stick firmly to figure's head, turning up side flaps and securing in an attractive position by stitching.

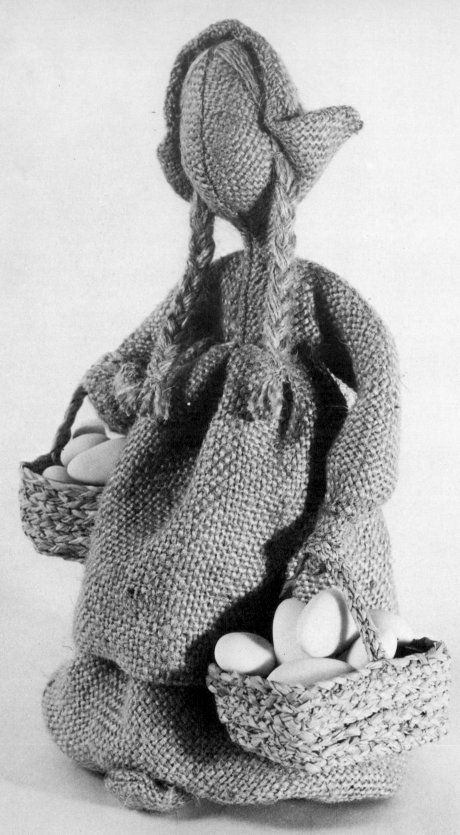

Dutch girl used as sweet holder

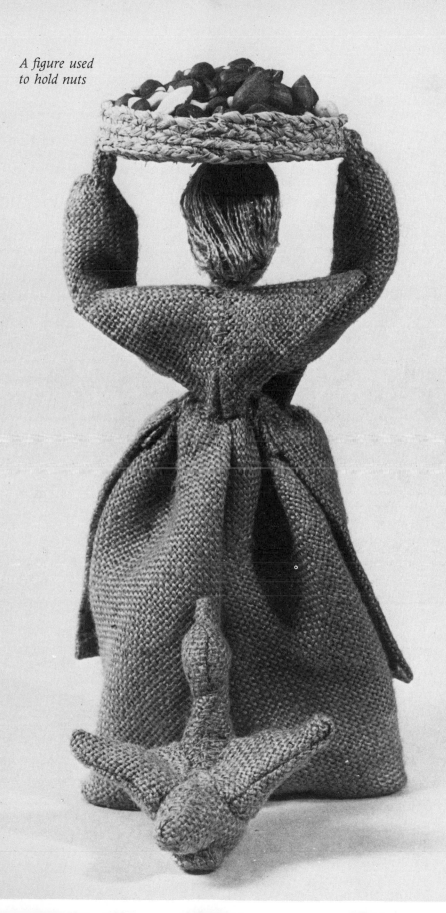

*A figure used
to hold nuts*

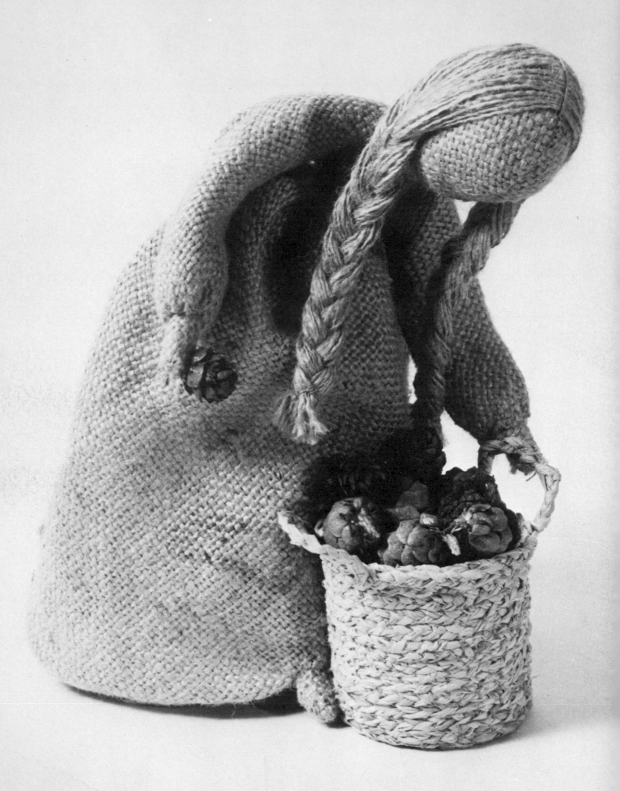

Gathering cones

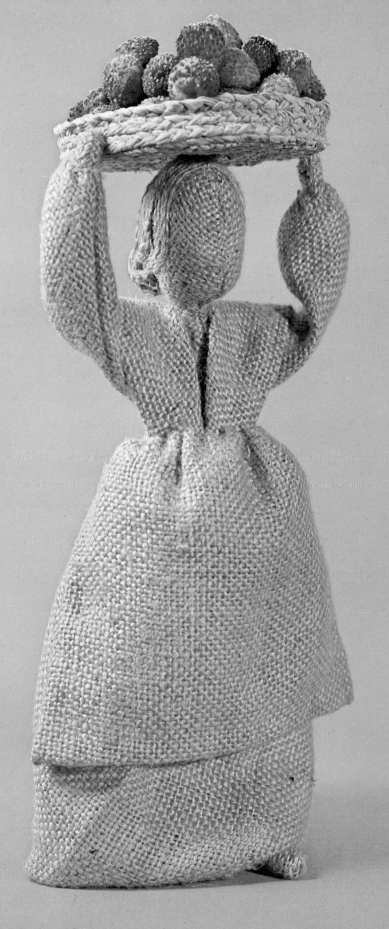

The Strawberry Seller

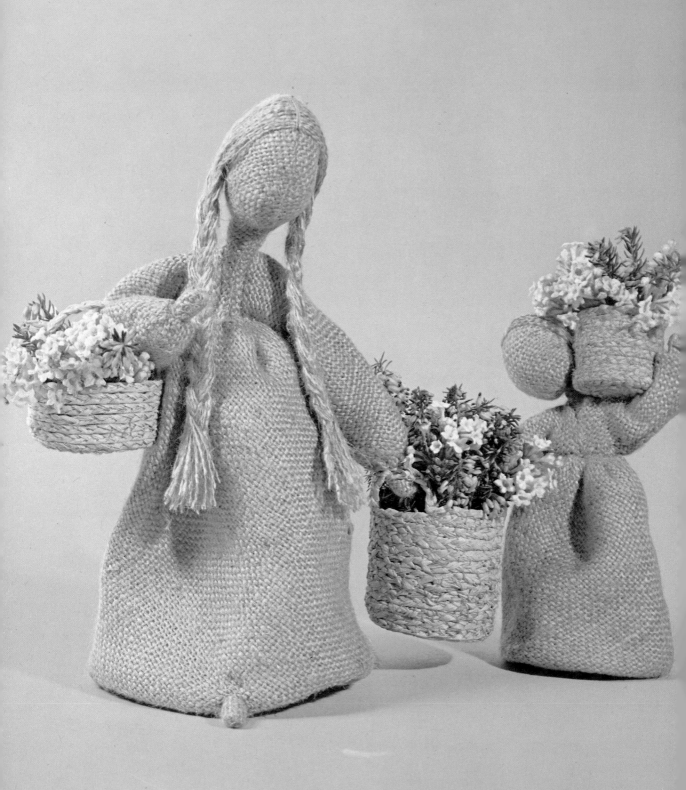

The Blossom Picker

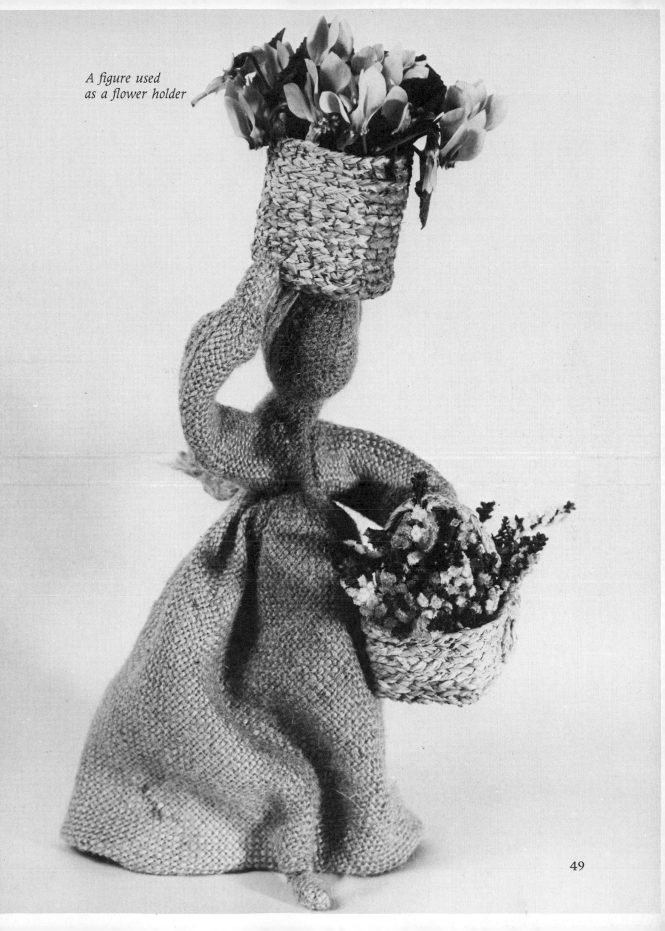

*A figure used
as a flower holder*

49

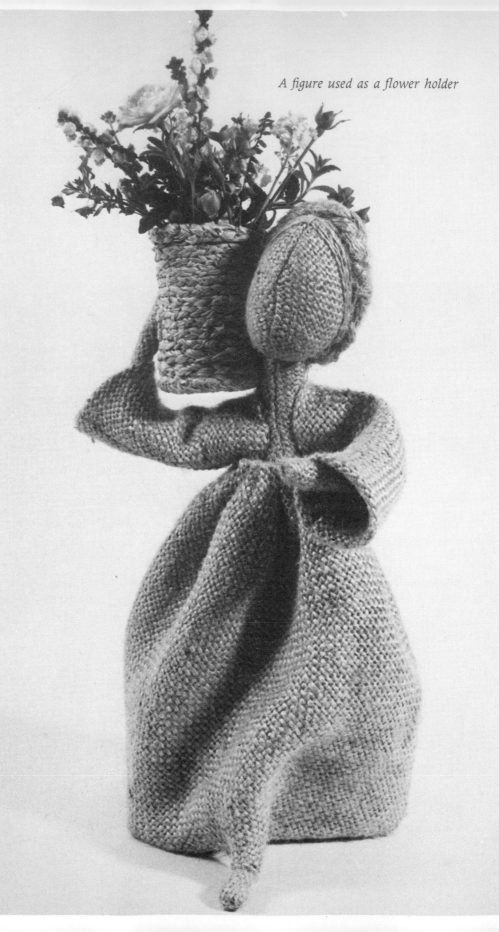

50

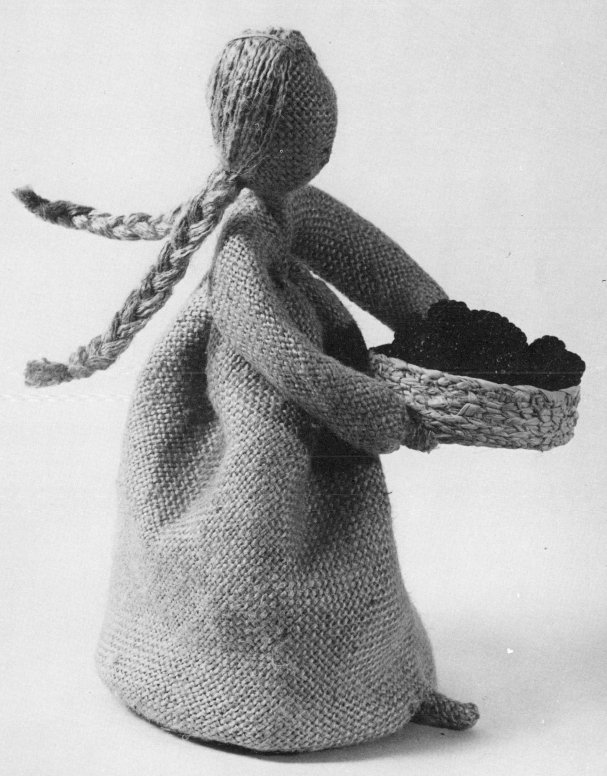

A figure used to hold blackberries

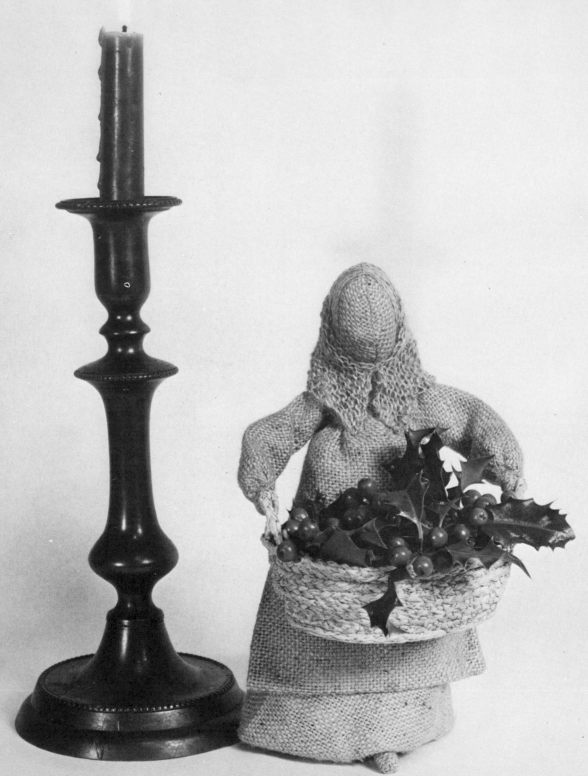

A figure used as a table decoration

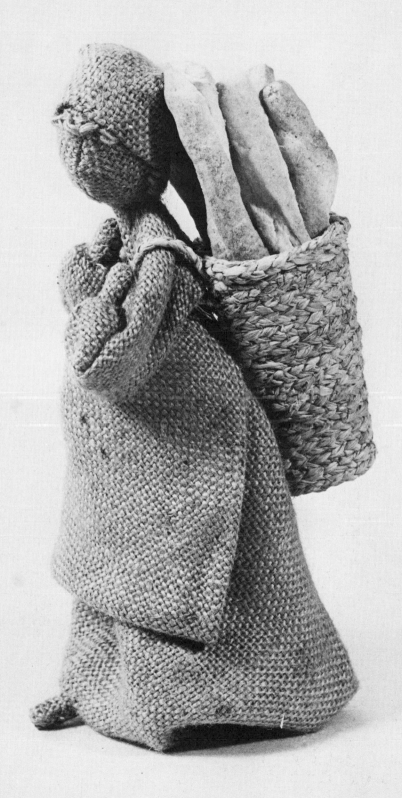

Peasant girl with bread (cheese straws) 53

THE BASKETS

Perfectionists may wish to make baskets woven in very fine cane. This is an art in itself and miniatures of this type are fully covered by Eve Legg in the appropriate section in *Toys from the Tales of Beatrix Potter*.* Many of the designs and methods described there could be adapted for use with hessian figures. (The address of a stockist where small quantities of fine cane may be obtained is also given there.)

Experiment showed, however, that these particular figures lend themselves more readily to crude little baskets simply made with natural coloured garden raffia, the raffia complementing the material perfectly.

Buy a hank of garden raffia, sometimes known as bass, from a seeds-man or garden centre. Don't buy synthetic raffia. It would quite spoil the effect of the finished model. Choosing three stout lengths of raffia, pin the ends first together, then to something solid, like the arm or back of an easy chair. Start to plait, or braid, tightly and evenly, intro-ducing a fresh length of raffia as soon as the end of any one piece begins to taper. Leave the end of the fresh piece protruding, then use it together with the remains of the old piece. Continue in this way until you have several yards of plait. If you intend to make many baskets, use up the entire hank. If some of the strands of raffia are thin, use two or even three together. When you have a sufficiently long plait, pin or stitch the ends together to stop them unravelling and work along the entire length snipping off all the protruding ends. Wind the plait into a ball or round a piece of card to stop it tangling while making the baskets.

Baskets that are to hold flowers and, therefore, water must be modelled round a water-tight shape that can be used inside as a container. There are many suitable things around the house: plastic pill boxes or jars, individual jam containers, or lids of aerosol sprays. Even the lower parts of plastic liquid detergent or shampoo bottles are easily cut to size with old scissors.

If the baskets are not to hold water, they may be shaped over almost anything. An individual pie dish makes a delightful clothes basket. This basket is too heavy for a figure to hold unless you remove the pie dish. The basket then may be filled with tiny cones, acorns, berries, nuts or, as on page 52, holly.

When making baskets of special or unusual design for which no lining is needed and for which you cannot find a basic mould, it is a

* *Toys From The Tales of Beatrix Potter*, by Margaret Hutchings. Published by Mills & Boon Ltd, London, and Frederick Warne & Co, New York.

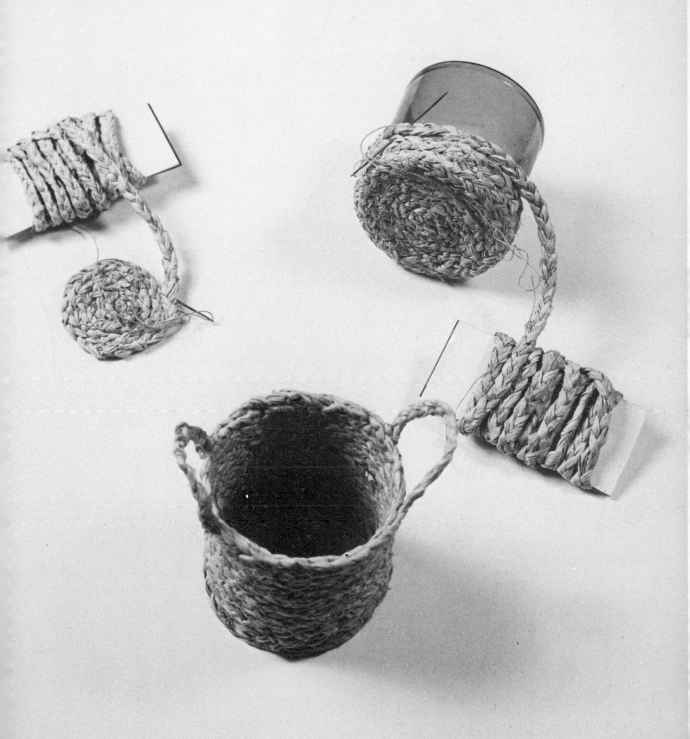

Making the baskets

simple matter to whittle the necessary shape from a piece of balsa wood, using an ordinary penknife. This was done in the case of the 'hutte', a basket slung on the back and much used on the continent for carrying bread, hay, etc. It is shown on page 53 containing cheese straws.

Having found a suitable mould for the basket you wish to make, turn it upside down. Using matching thread, sew the straw plait round and round until you have a flat base. Then, holding the mould and base in the left hand, continue sewing the plait to itself, working up the sides and enclosing the mould, which can easily be slipped out when the sides of the basket are completed (see page 55). A glance through the book will suggest many types of handles and finishes. A double thickness of plait looks attractive round the top, as do swirls and loops stitched flat to the sides for decoration.

Rectangular baskets are effective (see pages 46 and 49) and a small matchbox makes a good mould round which to shape them. Should you wish the basket to hold water, carefully line the tray part of the box inside and out with aluminium foil so that it is quite water-tight. Replace it in the finished basket. When making the base for this shape, work up and down the length of the rectangle instead of in a spiral, then stitch the plait round this as you start working up the sides.

If a basket should be at all loose or badly shaped when finished, merely slip it on to its original mould, thoroughly soak the whole thing in hot water and leave it to dry out overnight in a warm room. When the mould is removed the next day the basket will be crisp, neat and taut.

Fine rushes make enchanting little baskets, their subtle colours blending beautifully with the material used for these figures. Rush-workers may like to substitute these for raffia.

3 FIGURES FOR THE NURSERY

Child figures used either alone or grouped with adults make attractive nursery decorations. It is a simple matter to build up small tableaux by adding animals, toys, etc., and to create nursery rhyme and fairly tale characters. A few broad and easily adapted ideas are shown on the next few pages. Instructions are given for making the toys and for turning a basic figure into a witch.

THE TOYS

Marbles

These are peppercorns. Another view of the little boy playing with them is shown on page 92, where he appears on the extreme right, listening to the story-teller.

Balls

The originals were wooden balls from a handicraft shop. They have one hole drilled in them, being normally used for small dolls' heads. Stick the hand of the figure over the hole. Oak apples make a good substitute.

Hoops

Soak a small piece of cane in hot water and tie in place round a jam jar, leaving it overnight to set.

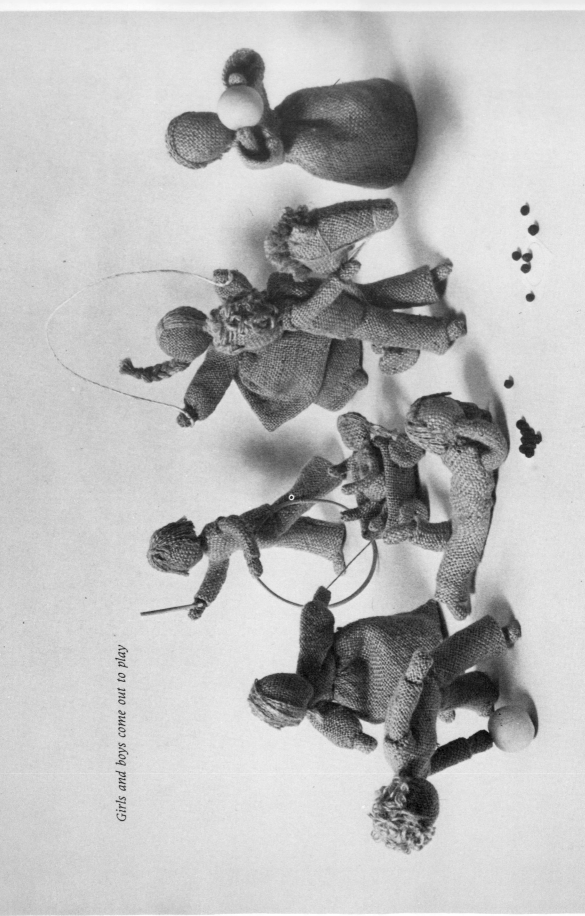

Girls and boys come out to play

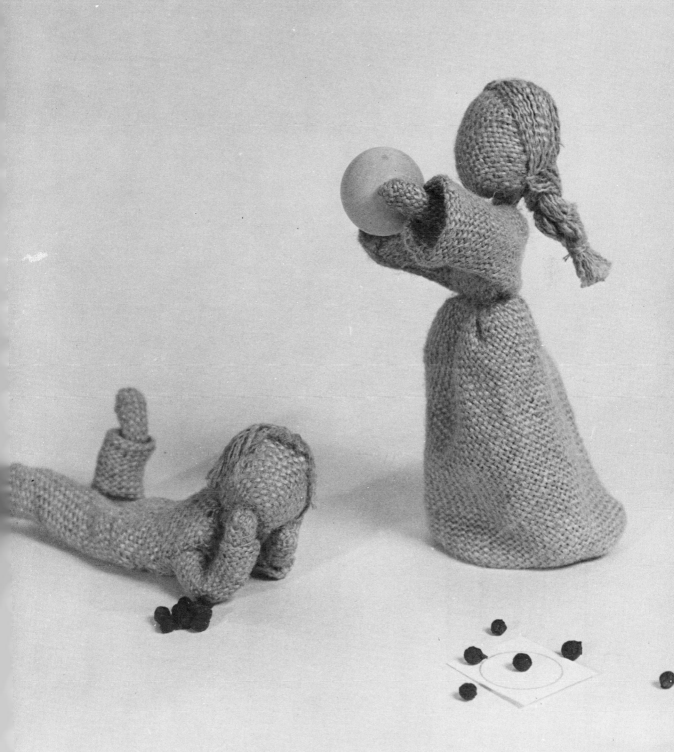

Marbles and ball

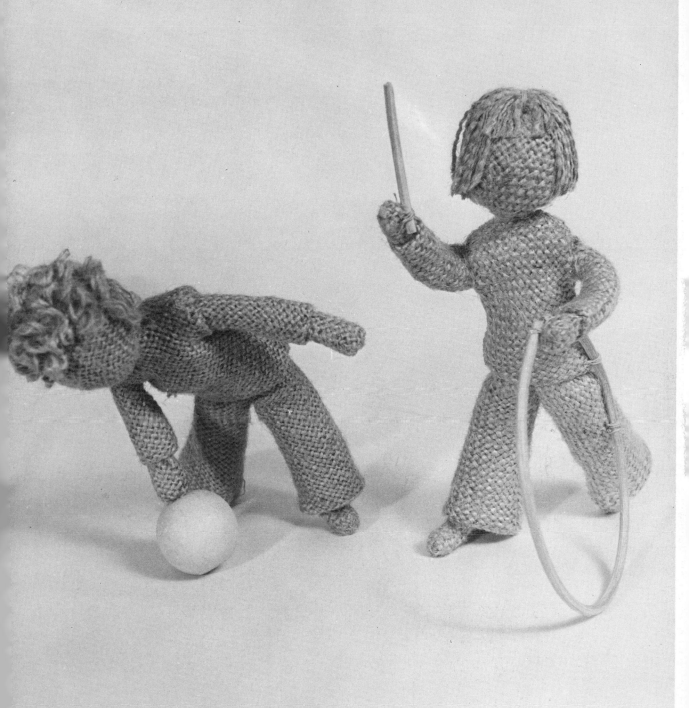

Ball and hoop

Doll (see also page 93).

Stage 1 Cover a button by placing it on a larger circle of material and gathering up at the back; this is the head. Cut a length of pipe cleaner $3\frac{1}{4}$ inches (8.2 cm) long for the arms, and one $3\frac{3}{4}$ inches (9.5 cm) long for the legs. Cover these with material and bend the legs to a hairpin shape.

Stage 2 Cut two small triangles of material for dress. Oversew them together from the top point down one side, tucking in the raw edges as you work and including the arms as shown. Oversew from the point down the second side, including the other end of arms.

Stage 3 Stitch point at top of dress to back of head. Stuff dress firmly, push the legs well inside, and oversew bottom of dress, including the legs as you work. Bend hands and feet slightly forward. Sew a small bundle of threads pulled from the material to top of head for hair. Catch neatly at each side and make two tiny pigtails. Stitch the ends and trim.

Cart

Cover the tray part of a small matchbox with material, sticking it down with adhesive. Cover four buttons with material, gathering it up at the back. Sew buttons to corners of the box. Draw a thread from the material to make the rope.

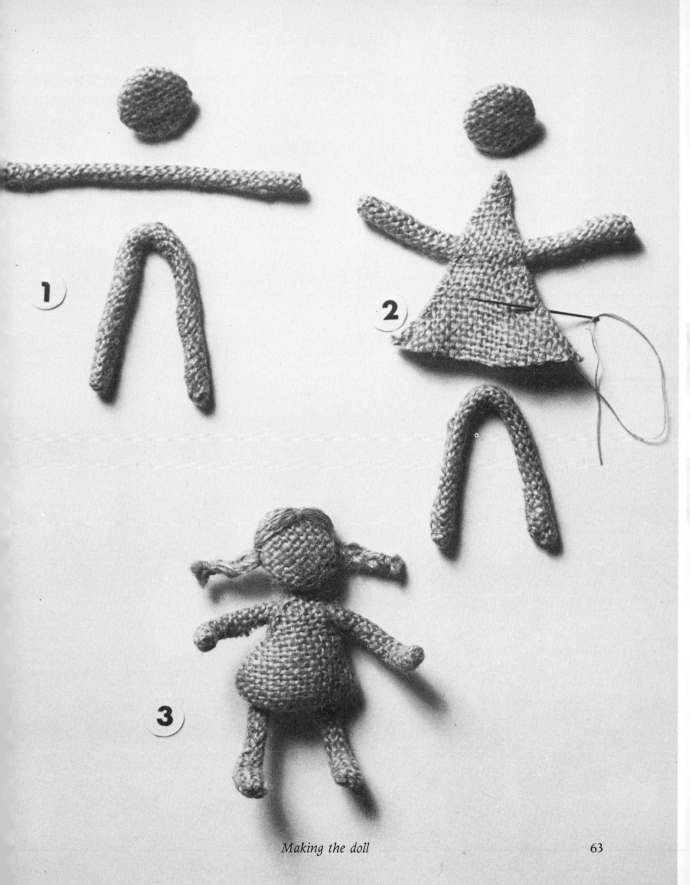

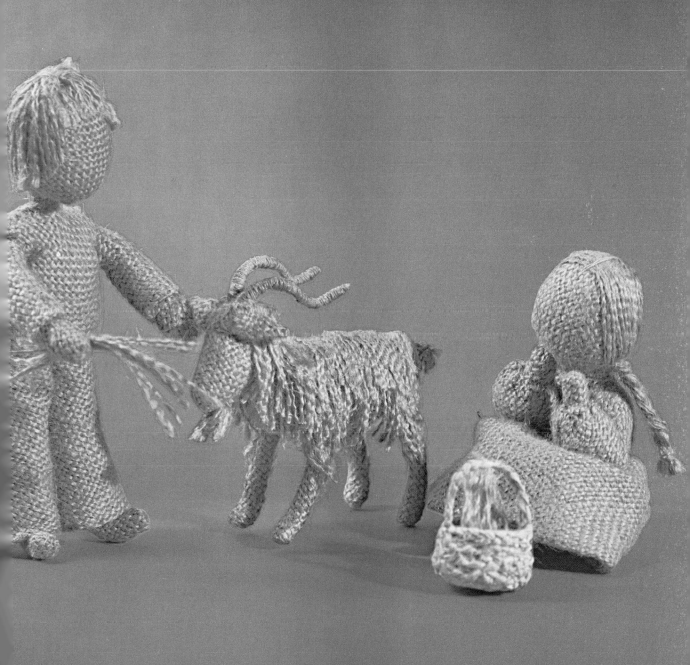

The Pet Goat

Hobby horse

This is a little fiddly to make, but well worth the trouble.

The pattern for the head is on page 108. Make a cardboard template, place it on double material and draw all round the edge. Machine twice all round the pencil line except for the short end A–B, then machine back again. Cut out the piece, leaving about $\frac{1}{4}$ inch (.6 cm) turning. Turn right side out. Stuff very firmly and place on one side, leaving the neck open.

Cut a piece of wire 5 inches (12.5 cm) long. Prepare and cover it as shown on page 12. Push this well up into the head. Gather round neck, turning in raw edge as you work. Ladder stitch head to covered wire, making sure it is all very firm.

Cover two buttons for wheels by placing each one in the centre of a larger circle of material, gathering all round the edge, and pulling up at back of button. Fasten off securely and sew one to each side of end of 'stick'.

For the mane, take a series of long, looped stitches from the top of the horse's head down to base of neck, using a thread drawn from the material. Work back again to the top of head, and back again to the neck, so that the loops are really thick. Spread a little adhesive along the base of the loops at each side and press together so that they stand erect. When dry, cut away the tops of the loops so that the threads are short. Tease out the ends of threads so that they are fluffy.

Make the ears from tiny triangles of material oversewn all round, with the raw edges tucked inside. Ladder stitch them in place. When *finished* the ears should be the size shown on page 108.

Make the reins and bridle by taking long stitches, using a long needle and threads drawn from the material. The picture will act as a guide. Arrange your little boy on the horse in an attractive position, stitching his hands to both neck and reins.

Skipping rope

Use very stiff string, or saturate a piece of string in glue and leave it to set in the required position.

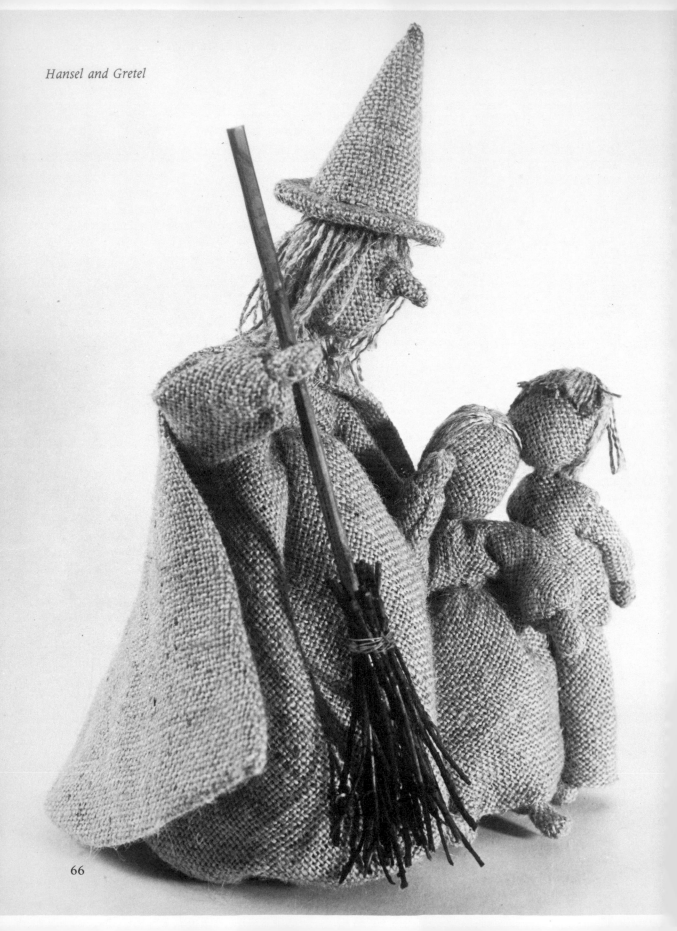

The witch

This unpleasant person can be used in many ways! She is shown opposite with Hansel and Gretel.

Start with a basic adult figure, but make the hair as shown for children on page 41. Leave it straggling loosely round her head and cut it in a very jagged, uneven way.

Make her nose from a triangle of material with curved sides. Fold the triangle in half and oversew, tucking the raw edges in as you work. Stuff very firmly and ladder stitch to face, so that it has a hooked effect. The finished size and shape is shown on page 108.

The pattern for the hat is on page 108. Cut out the brim in a very stiff cardboard. Cover it completely by placing it between two larger circles of material and oversewing all round the outside edge, tucking in the raw edges as you work. (Pins and adhesive are a help, as this is an awkward job.) You will then have a solid covered circle. Feeling with your needle as you work, stab stitch the two thicknesses of material together all round the inner ring of the cardboard stiffener. Plunge your scissors through the centre of the inner ring and slash the material in several directions towards the stiffened brim, so that you have various loose 'points' of material to stick up inside the crown. Place on one side.

Cut out the shape for the crown in stiff paper and stick it firmly to a larger piece of material. Cut out, leaving about $\frac{1}{4}$ inch (.6 cm) surplus material all round the edge. Fold the surplus to the back of the paper and stick in place. Curl the piece round to form a cone so that the side A–C rests on the broken line A–C on pattern and B is hidden underneath. Stitch firmly all down A–C working right through the paper. Smear adhesive round lower edge of cone and stick to brim. Then smear adhesive round inside of cone and press the loose points of material on brim to the cone until they are firmly set. If necessary, ladder stitch lower edge of cone to brim for added strength. Spread a little adhesive on witch's head, press hat well on and hold in place with a few pins until firmly set.

The pattern for the witch's cloak is shown folded four times on page 109. Cut a paper pattern the size shown. Then cut a full size pattern, which will, in fact, consist of four such pieces joined together to form slightly more than a quarter of a circle. Place the pattern on doubled material and draw all round the edge. Machine the two thicknesses together, leaving open a small section at centre back of cloak through which to turn it. Cut out, leaving $\frac{1}{4}$ inch (.6 cm) turning. Turn right side out. Invisibly oversew opening, then press well with a hot iron and damp cloth. Stick in place round witch's shoulders.

Make her a broom from a stick and small twigs.

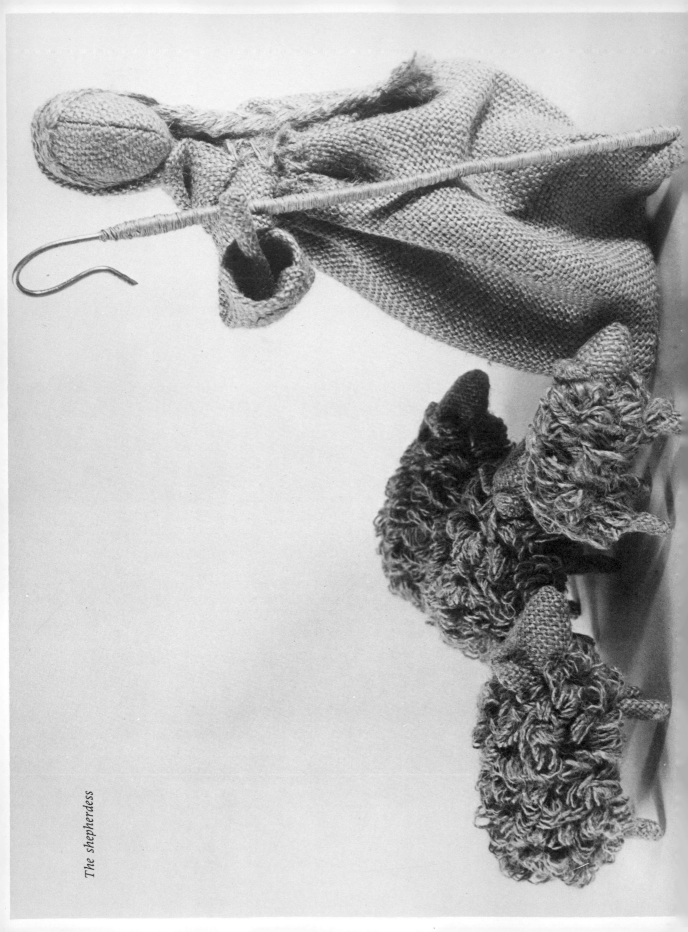

The shepherdess

4 SOME COUNTRY CHARACTERS

Most of the characters contained in this section are closely linked with animals, for which detailed instructions are given. The animals will be found useful for interchanging with many of the figures in other sections, particularly to create nursery rhyme people.

The shepherdess wears a hood made from a straight piece of material folded in half and joined down one side to make a centre back seam. Interest is added to her bodice by lacing across it with a double thread pulled from the material. Her crook is made of wire. Smear the handle with adhesive, then bind with button thread, working up and down several times and smearing each layer of thread with adhesive.

THE SHEEP

Stage 1 Cut a strip of material on the straight of the weave, 11 × 7 inches (28 × 18 cm). Do not machine all round the edge. Count eleven threads across the width, then draw out the next eleven; count eleven, then draw out eleven. Continue in this way until you have drawn out seven groups of eleven threads. Do not discard these threads. Now machine all round the edge of the piece to prevent it fraying.

Making the sheep

1

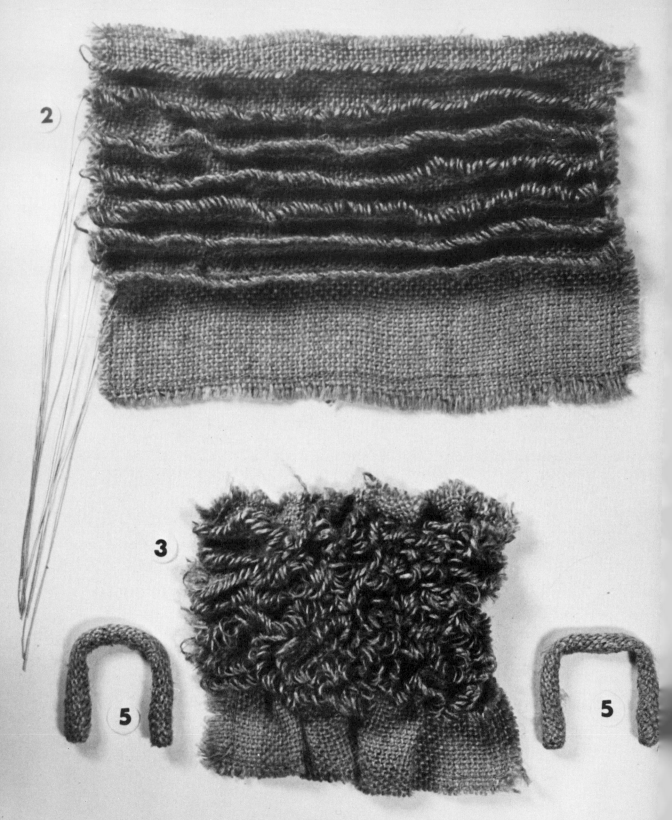

Making the sheep

Stage 2 Fold across the centre of the first panel of drawn threads. Run a gathering thread (large stitches) across the two thicknesses of solid material about three threads below the open panel of single threads, thus creating a 'pleat' of single threads. Leave a length of the gathering thread hanging and do not pull it up or fasten it off. Repeat all down the material on each open panel until you have seven pleats and a plain panel at each end.

Stage 3 Start at the beginning again and pull up each thread in turn, reducing the width of the material to $3\frac{1}{2}$ inches (9 cm). Fasten off each thread very securely. You should now have a fleece that consists of seven rows of curly loops. The rows run from head to tail on the finished animal and will soon mingle with each other.

Stage 4 Gather along each end of the fleece, that is, at head and tail. Pull up gathers as tightly as possible and fasten off very securely, tucking in the raw edges and odd threads as you work.

Stage 5 To make the legs cut two pieces of wire $3\frac{1}{2}$ inches (9 cm) long. Prepare and cover as given on page 13. Bend each one into a bridge shape, using strong pliers. Each leg should be $1\frac{1}{4}$ inches (3 cm) long and the crossbar, which will eventually go inside the sheep's body, 1 inch (2.5 cm).

Stage 6 Using pointed scissors, make two holes as near to each end of fleece as possible, placing them on the solid edge panels as close as possible to the first rows of loops on each side. Slip a prepared leg wire into each hole, so that the crossbar is inside and the legs protrude. Push the threads you originally drew out inside the fleece to stuff the body. Push the legs *well* inside so that there is stuffing between the crossbar and the seam you are about to make, and only about $\frac{3}{4}$ inch (2 cm) of each leg protrudes. Stitch in a criss-cross manner down centre of underbody, enclosing the stuffing and tucking in the raw edges. Ladder stitch the underbody to the top of each leg, working firmly all round each one several times. Adjust each leg as you work so that they are all the same length and your sheep will eventually stand well.

It is *very* important not to make the legs too long or the finished animal will have a very strange appearance.

Stage 7 The pattern for the head is on page 109. Cut this out exactly to size, allowing no turnings. As can be seen from the photos, the material can be either on the straight or the bias.

A Fold the material in half and, matching As, machine seam A–B, taking about $\frac{1}{4}$ inch (.6 cm) turning. Machine back again B–A (B is the nose). Turn inside out. Stuff firmly from the nose for about $\frac{3}{4}$ inch (2 cm), pushing stuffing very well in. Fold point A back so that it rests on X on the inside of head, keeping it in place with the thumb of the left hand, the forefinger pushing on the nose point B. With the right hand, tuck in raw edge all round D–C–D, then fold it down to cover the entire back of head, and oversew all round.

B Stab stitch across top corners, which contain no stuffing, to make ears, leaving a small gap between them.

C Take a few stitches over the top of head from front to back at the inner edge of each ear to make them stand up, then ladder stitch them slightly forwards.

Make sure the head is not too large for the size of your sheep.

Stage 8 Pin head to one end of the prepared body, trying various positions in order to get the best effect. Ladder stitch it firmly in place, working all round. Make sure you draw the head tightly back against the prepared fleece as you work. To achieve the typical appearance of a head half buried in the wool, pull the curls of the fleece forwards, stitching them to the head here and there if you think it necessary.

No two sheep ever turn out exactly the same size or shape. This is convenient if you want to make a flock, as it gives a more natural appearance to the group. Should you want to vary the size even more, make one or two larger by drawing the material for fleece up to 4 inches (10 cm) instead of $3\frac{1}{2}$ inches (9 cm) at Stage 3. To make a smaller sheep cut a narrower and shorter piece of material in the first place, so that you have only six rows of curls on the fleece instead of seven, and when drawn up they are 3 inches (7.5 cm) wide instead of $3\frac{1}{2}$ inches (9 cm).

You could make a ram for your flock by adding curly horns to a sheep.

Always make an odd number of sheep in any one group; three, five or seven are good numbers.

Making the sheep

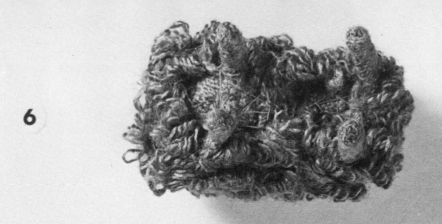

6

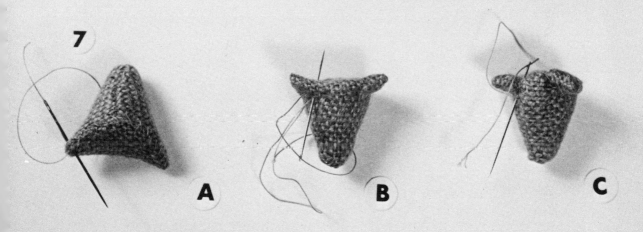

7

A B C

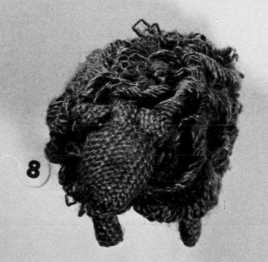

8

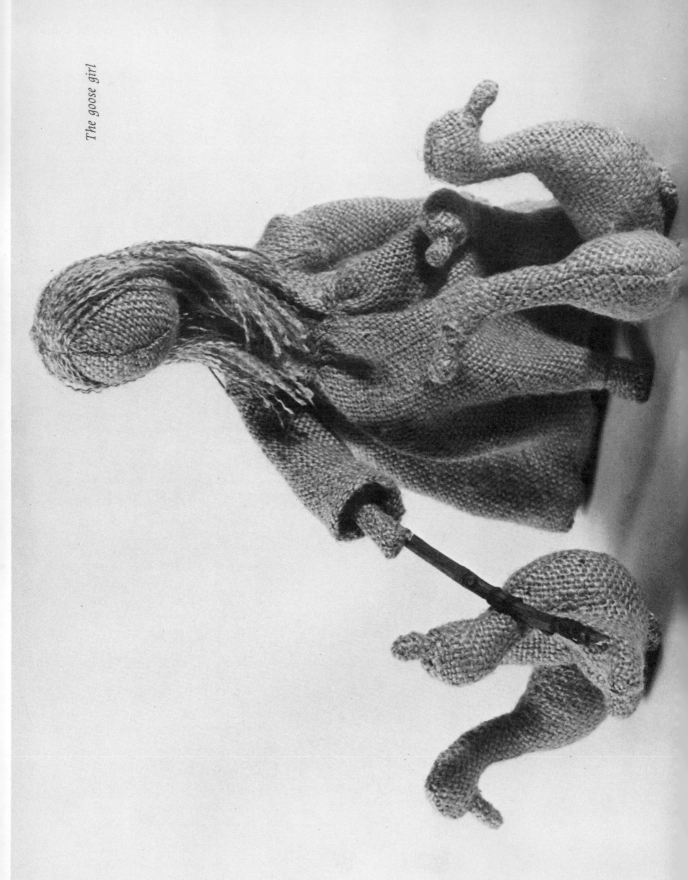

THE GEESE

The pattern for a goose's body is on page 111. Cut out a template, place it on doubled material and pencil all round the edge. Machine the two thicknesses together all round the pencil line, except the short section A–B. Machine back again. Cut out, leaving approximately $\frac{1}{4}$ inch (.6 cm) turning all round the machined part, and slightly more each side of opening. Turn right side out, pushing tail and head well out with a blunt cocktail stick or similar item.

Cut a piece of wire approximately 3 inches (7.5 cm) long, and prepare and bind it as shown on page 12. This serves two purposes; it stiffens the neck of the goose and forms the beak. Bend the wire to the contour shown by line of Xs on pattern. Make a tiny hole in the front of goose's head and ease wire in *from* the outside *to* the inside. This is important, as the covered wire will tuck in the raw edges round the hole as you push it in. Leave just enough wire protruding to form a beak. Then using fine cotton thread, ladder stitch head to beak, working neatly and firmly several times round the hole. Adjust wire inside goose. Stuff head with the help of a cocktail stick. Then stuff body and neatly close opening at back of neck, pushing in any more stuffing that may be needed at the same time.

Make a tiny pad of material about $\frac{3}{4} \times \frac{1}{2}$ inch (2 × 1.3 cm) by folding and rolling a snippet, tucking in the raw edges and oversewing. Sew this to base of goose to simulate feet and in a position that enables the bird to stand up.

If making more than one goose, the positions and characteristics may be varied by altering the point at which the beak emerges from the head, so that some appear to be looking up, and some down. The necks may also be twisted and bent to give variety.

Normally these geese do not require wings, but it is a good idea to add them to just one, so that he appears to be hissing and generally behaving badly! (See also page 47.) The pattern for the wings is on page 111). Cut a template and place it on the material, which has a fold at C–B. Pencil C–A–B and cut out on pencil line. Machine twice along A–B and turn right side out, pushing out point B. Make another wing in the same way and push a little stuffing in both. Open out the base C–A–C and pin a wing to each side of one of the geese, having the folded side C–B to the front of each one. Ladder stitch wings to body all round C–A–C.

If making a flock to be grouped with a figure, like the goose girl opposite, it is a good idea to stick or stitch the birds and figure together so that they stay in attractive positions.

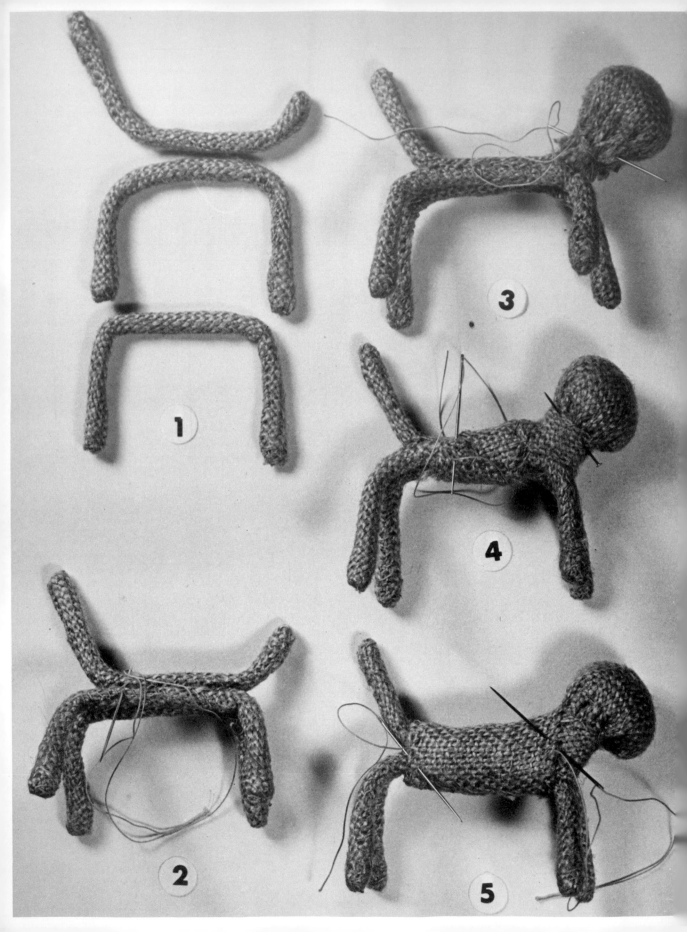

THE CAT

Stage 1　Cut two pieces of wire each $4\frac{1}{2}$ inches (11 cm) long and one piece $3\frac{1}{2}$ inches (9 cm) long. Prepare and cover them as shown on page 12, but keep them as slim as possible by using a strip of material barely 1 inch (2.5 cm) wide for binding. Use pliers to bend the two long pieces into bridge shapes for the legs and body, having the top, straight piece 2 inches (5 cm) long and each leg $1\frac{1}{4}$ inches (3 cm) long. The shorter piece forms the tail, reinforces the body, and supports the head. Bend $1\frac{1}{2}$ inches (3.5 cm) upwards at one end for tail, and $\frac{3}{4}$ inch (2 cm) upwards at the other end to support the head, leaving $1\frac{3}{4}$ inches (4.5 cm) straight for the body. Have the seamed edge underneath in all cases.

Stage 2　Sew the two leg pieces firmly together along top, straight edge. Sew the third piece to the first two, starting at the head end. You will notice that this third wire has a slightly shorter body piece than the other two so that the tail turns up before the legs turn down. This is necessary to give a cat-like shape to the back legs of the finished animal.

Stage 3　The pattern for the head is on page 110. Cut out a circle of material this size. Gather all round the circle, *not* on the broken line shown on pattern, but $\frac{1}{2}$ inch (1.3 cm) in from edge. Pull up gathers, stuffing the circle to form a little knob. Push over short end of body wire, easing the end of the wire well up into the stuffing. Pull up gathers very tightly round neck and stitch round and round until the head is firmly anchored, with the plain top of knob facing forwards for the face.

Stage 4　Cut a strip of material 1×5 inches (2.5×12.5 cm). Crease and fold the long raw edges back, reducing the width of the strip to $\frac{1}{2}$ inch (1.3 cm). Place round cat's neck, having the centre of strip to the front of cat under the chin. Pull tightly, crossing the ends over top of body at back of head. Pin, then stitch firmly in place, thus covering raw edges of head circle. Stitch all round neck at top and bottom of strip.

Read Stage 7 before proceeding.

Stage 5　Cut a piece of material 3 inches (7.5 cm) square. Fold two of the edges under so that you have a strip the width of your cat's back, from back of the head to the tail. Roll this round the body like a tight bandage, having the seam at centre under tummy. Oversew firmly in place along seam and all round both ends, then catch the piece together from side to side between tail and top of hind legs.

Stage 6　Now look at the picture of the cat on page 81. Make two

small triangular ears by folding a small square of material diagonally, tucking in the raw edges and oversewing. The finished size is shown on page 110. Stitch ears to top of head with a small gap between them. Model the face by taking a few stitches from one side to the other, pulling them tightly to raise the bridge of the nose. Take a few tight stitches up and down at each side of face to puff out cheeks. Insert a few whiskers using matching button thread. Keep them in place with a small dab of adhesive where they emerge.

Stage 7 With strong pliers, bend cat's body and legs into a realistic shape to suit the character or situation you are portraying.

If you have a certain position in mind before you start making your cat, you will find it easier to bend and shape him at Stage 4 before covering the body.

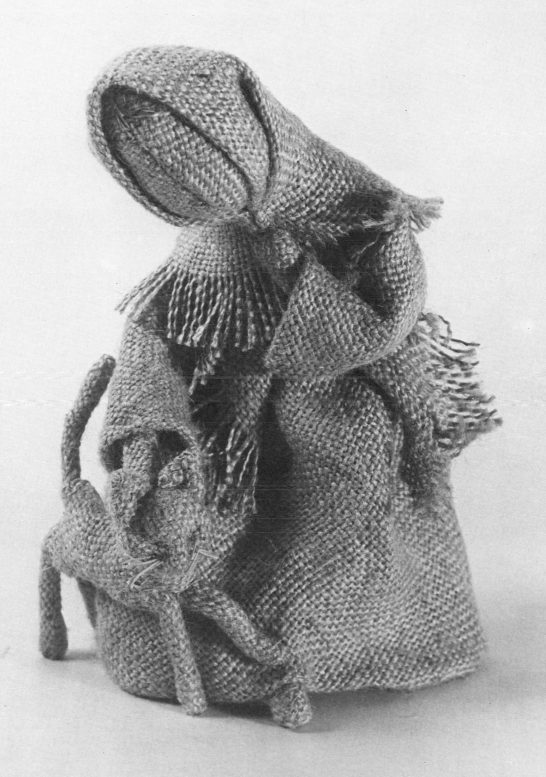

Old woman with cat

THE GOAT

Stage 1 Cut a piece of material $3\frac{1}{2} \times 3$ inches (9×7.5 cm). Fold in half lengthwise. Stitch the longer edges together, machining twice. Gather all round one end of resulting tube, pull up gathers and fasten off tightly. Turn inside out. Stuff firmly. Gather all round open end, turning raw edges well in as you work. Pull up gathers and fasten off, thus making a sausage shape about $2\frac{1}{4}$ inches long (5.5 cm). Prepare two leg wires exactly as for the sheep (page 73). Bend to U shape and turn the ends very slightly forward for feet. Prepare a head exactly as for the sheep, but don't stitch across corners for ears. Run a gathering thread across top of head from corner to corner and pull it tightly to narrow down the head.

For the horns, take a pipe cleaner and smear $1\frac{1}{2}$ inches (3.5 cm) at each end with adhesive. Bind these ends with button thread, making them fatter towards the joined ends by binding this part several times. Smear adhesive over each layer of thread, and over the completed horns. Bend to an attractive shape and leave to set very hard.

Stage 2 Stitch one wire to rear end of body for hind legs and one a little further forward for front legs, leaving a gap of about 1 inch (2.5 cm) between the two pairs of legs. Stitch head as shown to top corner of body. Sew a small bundle of long threads under chin in preparation for the beard, and another bundle to the rear for the tail. Smear both bundles with adhesive and coax and pull into required positions. Leave to dry.

Cut the prepared horns from the pipe cleaner and stick to top of goat's head, using a large amount of adhesive and holding in place until dry. It is sometimes possible to prop the horns in position with a thimble while the adhesive dries. When thoroughly set, spread more adhesive round and between horns for added strength.

Stage 3 Prepare a piece of material as shown, long enough to stitch from the top of the goat's head to rear end of body. Pull out all the cross threads except about three in the centre to hold it together. Cut the resulting fringe unevenly and so that when stuck to the goat's back (solid strip down centre) it will completely cover the body.

Stage 4 Smear adhesive over body and stick 'hairs' in place, pressing well down. Add a second layer of material prepared in the same way, but with slightly shorter hairs. Finally, stick loose threads of varying length across the back from head to tail. Trim the coat so that it looks thoroughly shaggy. Trim tail and beard to shape. Make up two ears to shape and size shown on page 110 by doubling triangular pieces of material and seaming. Stick and stitch in place.

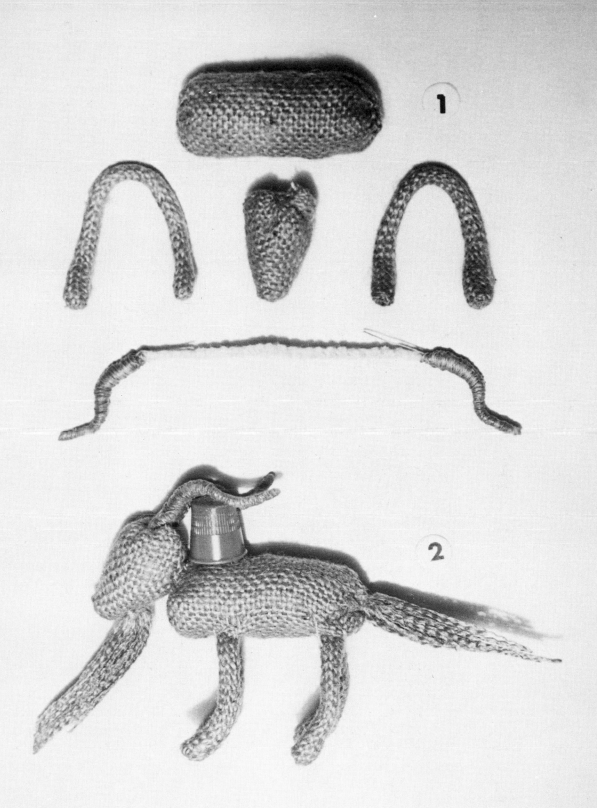

Making the goat

3

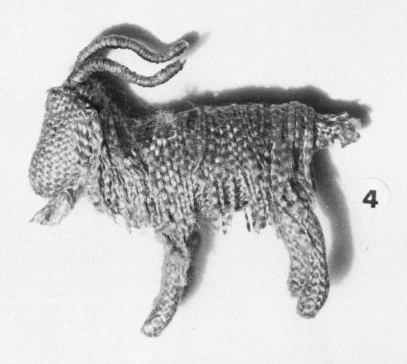

4

Making the goat

THE HEDGEHOG

The hedgehog on this page and on the colour plate facing page 65 is quickly made from a very small teasel. Trim off all the long bracts round the stalk. Cut the stalk to a short stump for the snout. Trim all the prickles until the teasel is the right size, cutting the underside flat so that it stands firmly. Cut two short lengths of stalk and, pushing them among the prickles, stick them in place for legs. Push a pin with a tiny black bead threaded on it into the snout for the nose, and one each side of snout for eyes.

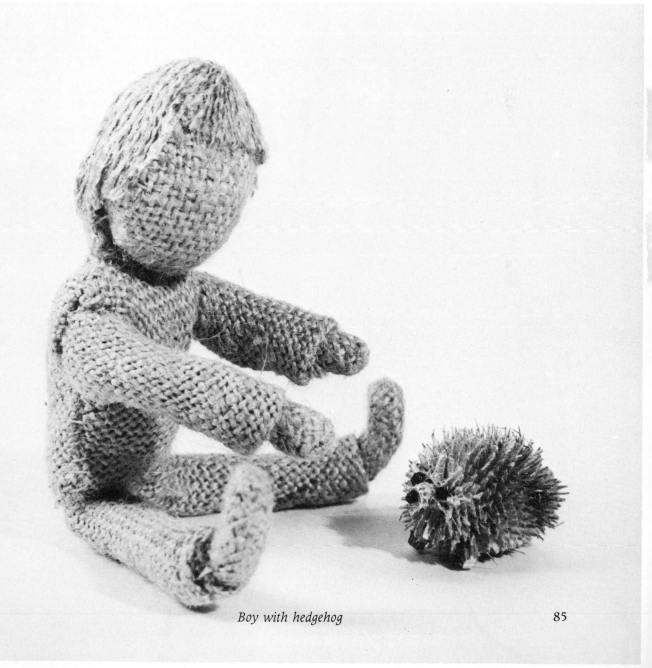

Boy with hedgehog

THE TORTOISE

The tortoise opposite is merely a walnut shell and five sections cut from beechnut husks. Draw the markings on the shell with a felt pen, then stick the legs in place, prickly side up, and the head smooth side up.

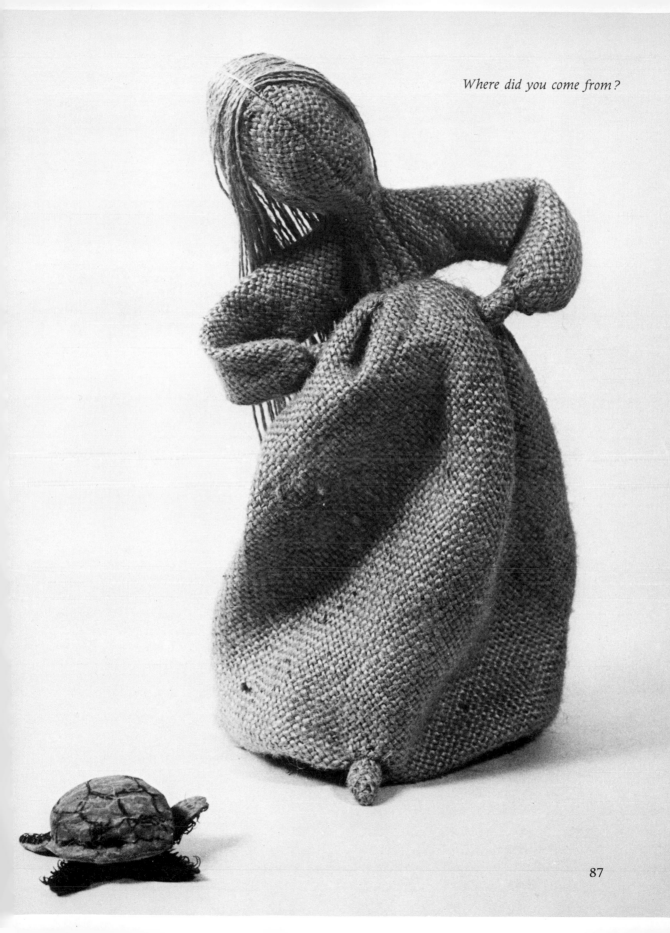

Where did you come from?

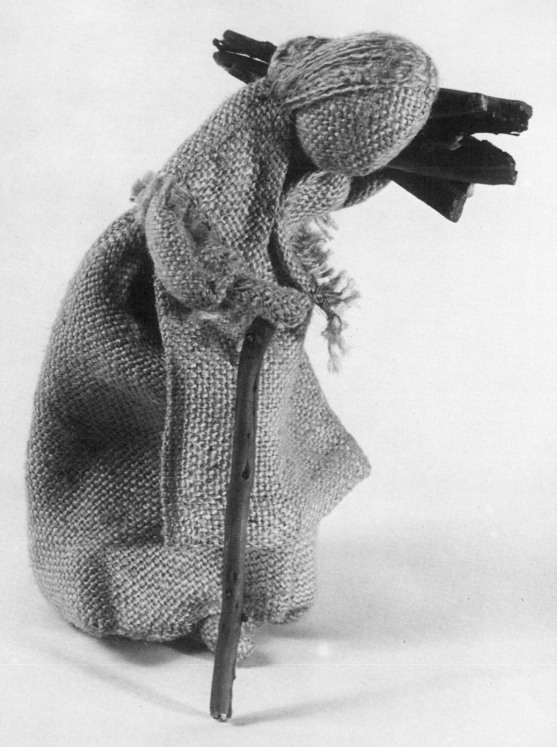

The wood gatherer

5 FAMILY LIFE

The figures in this section depict the numerous little day-to-day happenings in almost every family when mothers and grandmothers, aunts and big sisters are alone with the younger generation.

The mother winding the wool (which is a long thread pulled from the material) sits on a covered rectangular tin, while the storyteller sits on a log. The little boy on the extreme right of the log is pictured from another angle playing marbles on page 59.

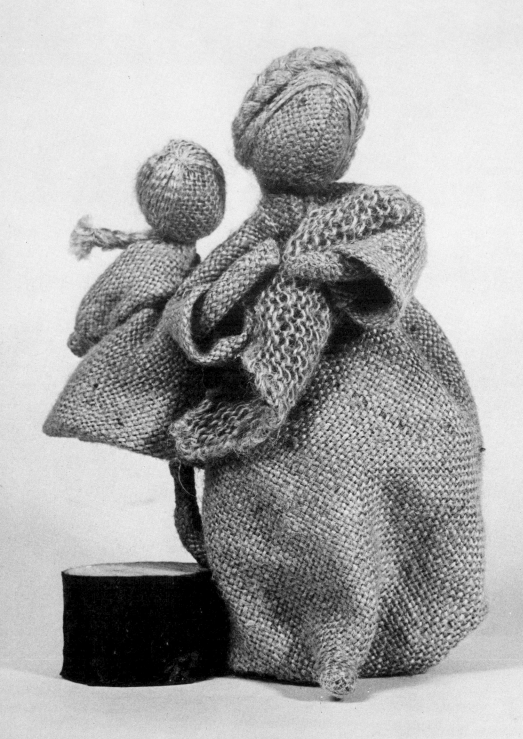

The new baby

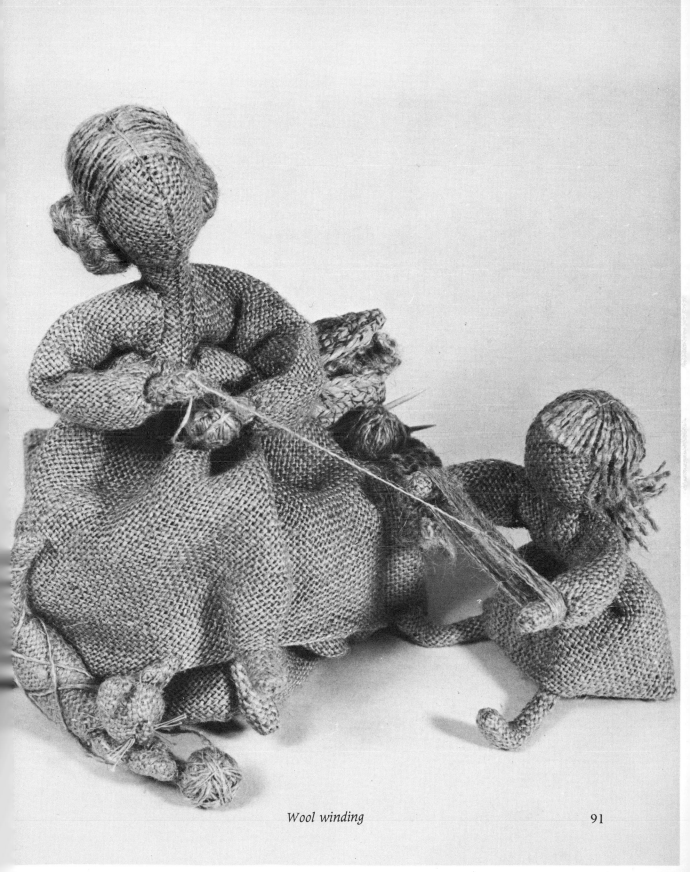

Wool winding

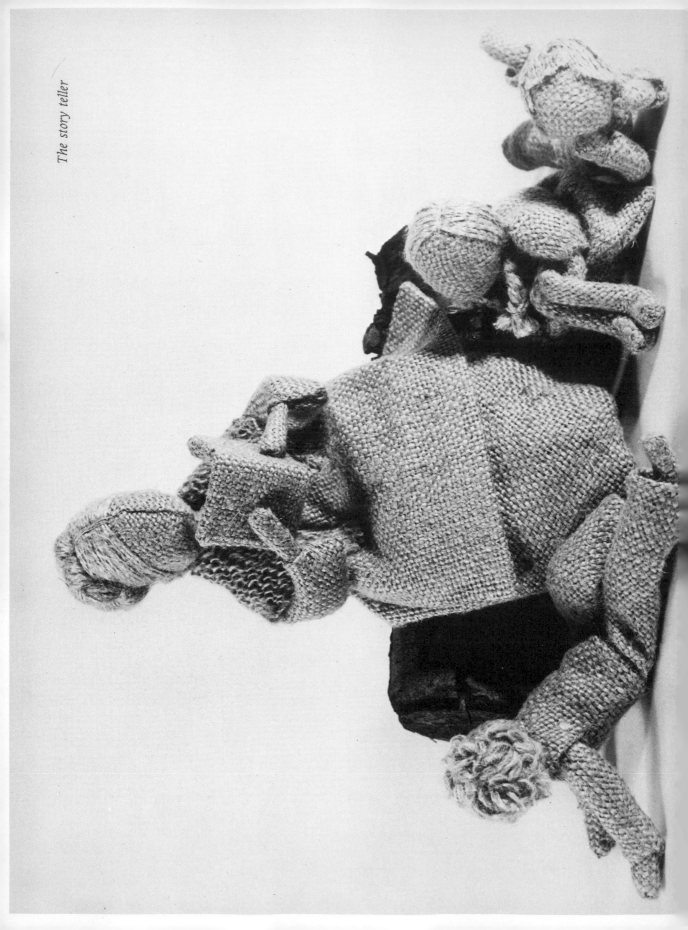

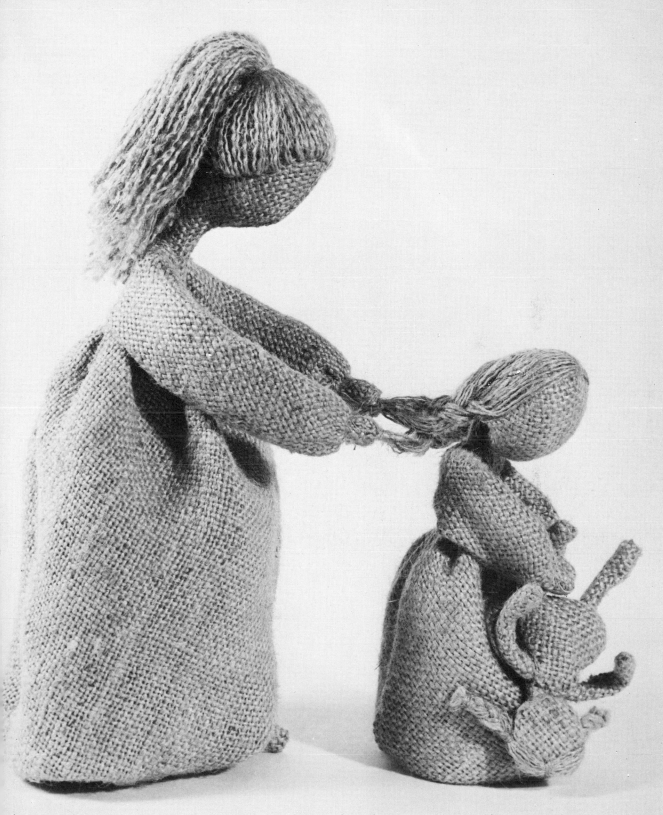

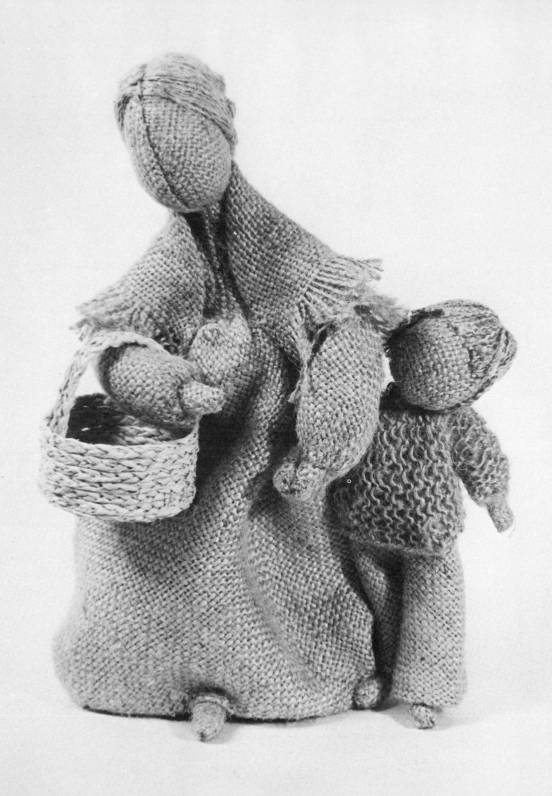

Shopping with Granny

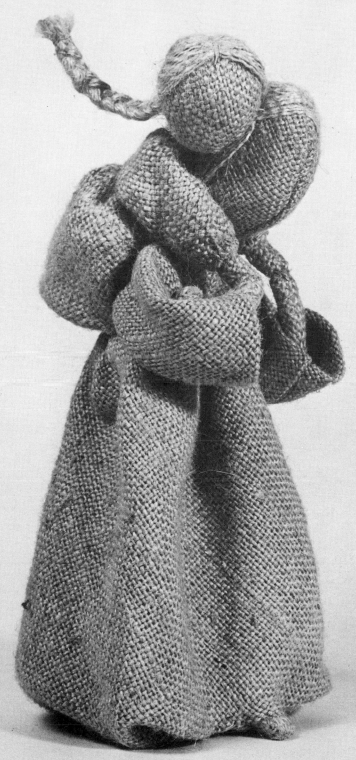

The piggy-back

6 FIGURES FOR CHRISTMAS

The picture opposite shows how attractive these figures are when used for a Christmas crib, their utter simplicity somehow appearing 'just right'.

All the figures, except the baby angel, are made from the basic adult shape and all the men have beards. The hair styles are made as for the children on pages 40–41.

STRAIGHT BEARDS

Sew small bundles of threads pulled from the material to the face, along the growth line of the intended beard. Tease out the threads a little with a pin, spread thickly with adhesive, coaxing and pressing to shape. Trim. A beard can be short and stubbly (the shepherd), long but shaped and curving slightly outwards (Joseph), long and pointed (the first king), or long and straight (the second king).

CURLY BEARDS

Take a series of long, looped stitches all round the jaw as shown for the short, curly hair on page 41. Shape it well by placing the stitches carefully and making those under the chin longer to bring the beard to a point.

MOUSTACHES

Incorporate these with the beard by sewing a small bundle of threads just under where the nose would normally be. Spread well with adhesive and tweak and twist to shape before stitching again here and there (see the first and second king).

ROLLED BANDS

Bands round the shepherd's head, the first and third kings' crowns, and the first king's gift were made by rolling a strip of material round a length of pipe cleaner and oversewing in place. The result is a long, pliable roll that can be stuck round any part of a figure for decoration.

The following notes on the original models may be helpful, but a crib is such an individual thing that each worker will probably prefer to invent her own methods for dressing the characters.

THE SHEPHERD

The head shawl is a square of material with the front corner turned under. It is kept in place with a rolled band.

The pattern for the sleeveless coat is on page 112.

Before cutting out, read through these instructions and make sure you understand them. Cut a template, noting the fold along top D–D. Open the template out flat and slit A–B on *one* side only (the front).

No turnings are allowed so cut out two pieces of material the shape of the template allowing a little extra for turnings. Machine the two pieces together all round, starting at the back lower edge C–D–C–B–A–B–C–D–C. The lower edge at back C–C is still open. Turn the coat inside out, push out corners and press carefully. Invisibly oversew C–C. You now have a double coat. Fold it in half across shoulders, try it on the shepherd (slit down centre front). Take the coat off the figure and, leaving plenty of room for the arms, oversew side seams on the wrong side.

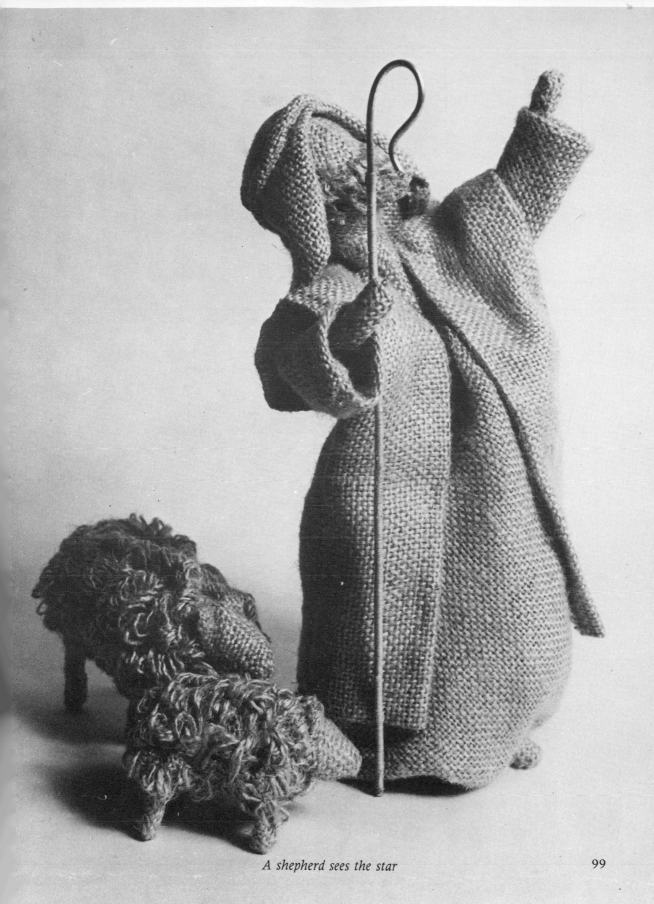

A shepherd sees the star

JOSEPH

This is a plain basic figure with a strip of material 4×18 inches (10×46 cm), stitched, stuck and folded round his head and shoulders to give the effect of a hooded head scarf. Pin the strip carefully before attaching permanently, trying this way and that to get the best effect.

MARY

To make her veil cut a semi-circle of material 6 inches (15 cm) in diameter, having a selvedge along straight, front edge. Spread a scant smear of adhesive all round back raw edge to prevent fraying, or invisibly machine round this edge. A hem would make the finished veil too bulky and clumsy.

THE MANGER

Cover a small box with material, sticking it in place, and fill with hay. There is no baby inside.

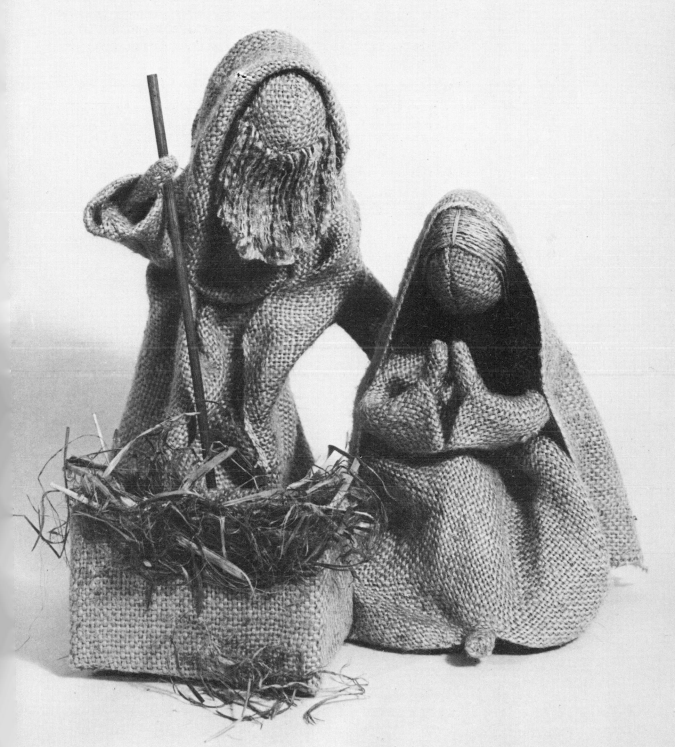

Mary and Joseph

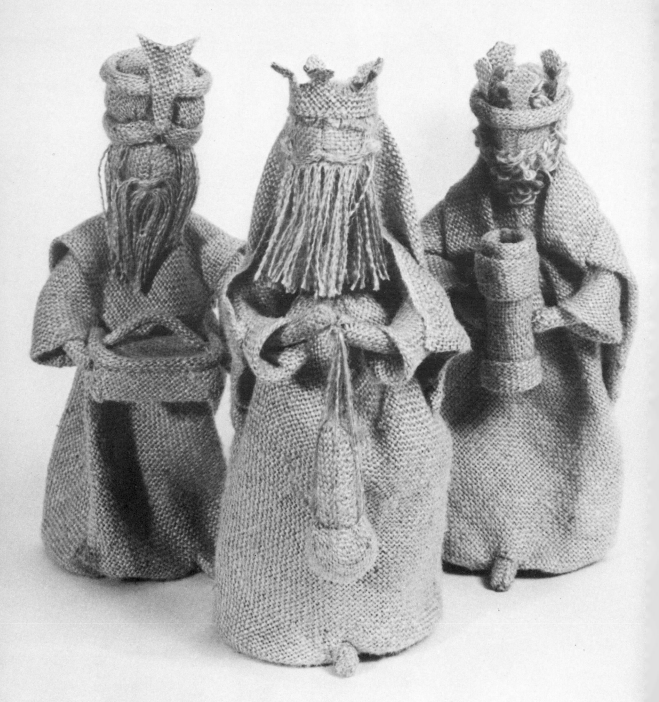

The Three Kings: front view

FIRST KING

His turban-cum-crown is a ball, made from a circle of material gathered all round the edge and stuffed. His plume is doubled material stuck together, then cut to shape. His gift is a covered match-box, and both it and his crown are decorated with rolled bands.

SECOND KING

His crown is doubled material stuck together, cut to shape, and the ends bent outwards while the adhesive was still wet.

His gift is a wooden ball covered with material, with another strip of material wound round the gathers and raw edges made by doing this. He holds it by threads drawn from the material.

THIRD KING

His crown is a rolled band with shapes cut from two thicknesses of material stuck inside it. His gift is a long, slim thread spool, covered with material cut on the straight and decorated with double bands cut on the bias as a contrast.

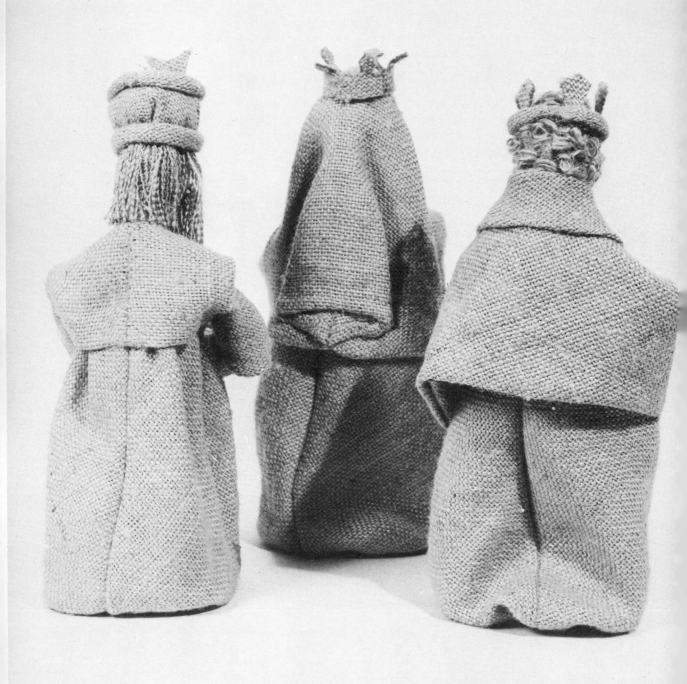

The Three Kings: back view

THE CLOAKS

Patterns for the first and third kings' cloaks are on page 110. They should be made up of doubled material, then turned right side out, *or* of single material with small turnings stuck back before attaching to the figures.

The second king wears a large semi-circular head shawl with a selvedge along the front, straight side, and the raw curved edge turned back and stuck in place.

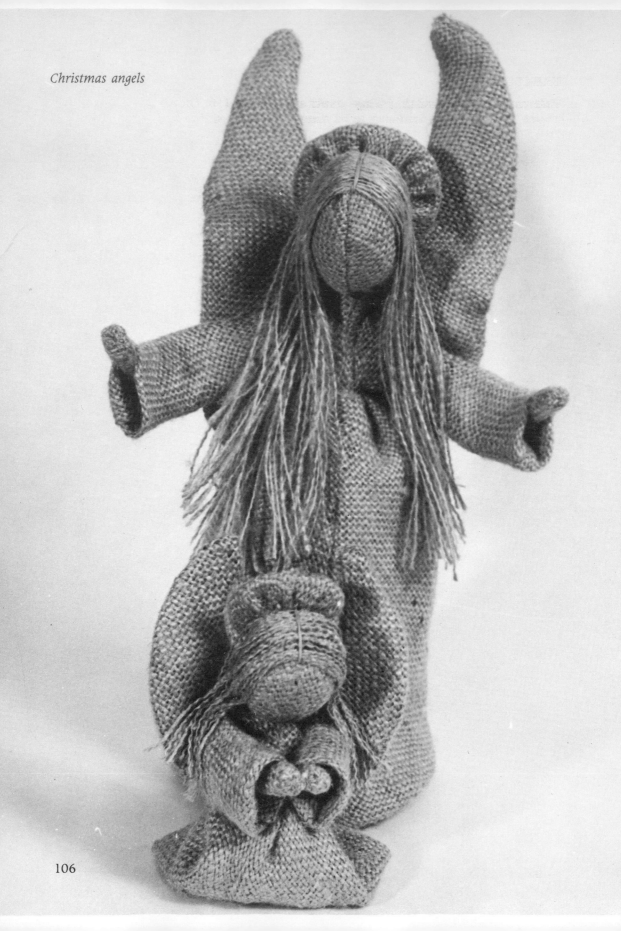

Christmas angels

THE ANGELS

The patterns for their wings are on page 111. Cut out a template in stiff paper. Pencil all round the template on doubled material. Stitch the two thicknesses together all round pencil line except for a short space between the two As. Machine all round a second time. Cut out wings leaving a small turning, turn right side out, pushing out points well. Cut the paper template a little smaller all round, then push it inside wings as a stiffener. Oversew opening and stick to angel's back.

To make the halos, cut circles of stiff cardboard and cover by placing each one on a larger circle of material, pulling up the gathers and fastening off. Stick to the angel's head gathered side forward, thus hiding the place where the gathers meet in the centre of halo and giving the effect of rays.

The larger angel is not shown in the crib scene on page 96, but you can include her with your own figures if you wish. She is also very attractive used as a Christmas decoration standing beside a candle or bowl of holly.

PATTERNS

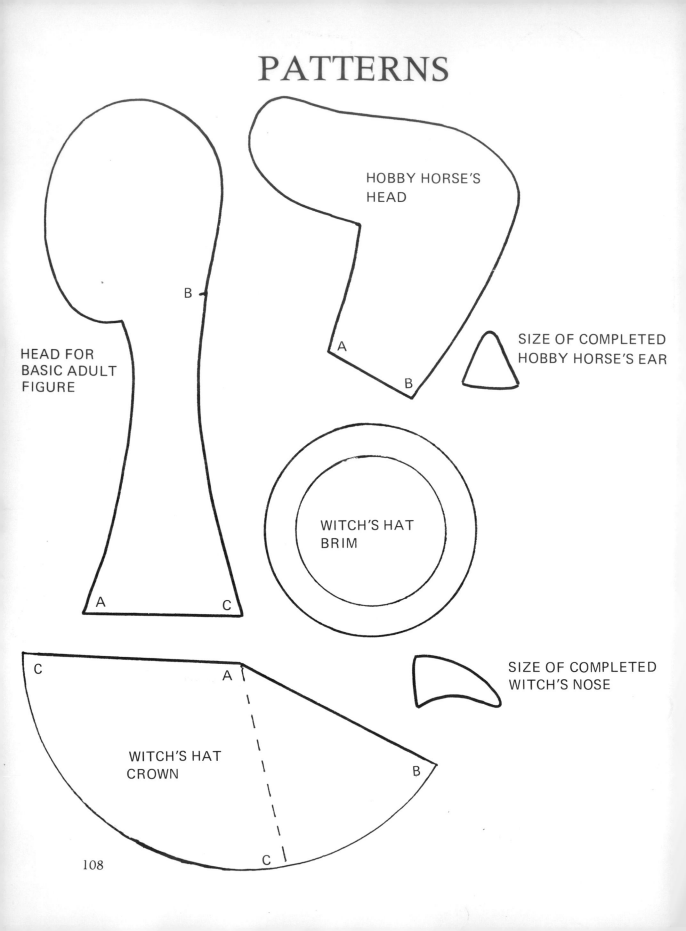

HOBBY HORSE'S HEAD

HEAD FOR BASIC ADULT FIGURE

SIZE OF COMPLETED HOBBY HORSE'S EAR

WITCH'S HAT BRIM

SIZE OF COMPLETED WITCH'S NOSE

WITCH'S HAT CROWN

108

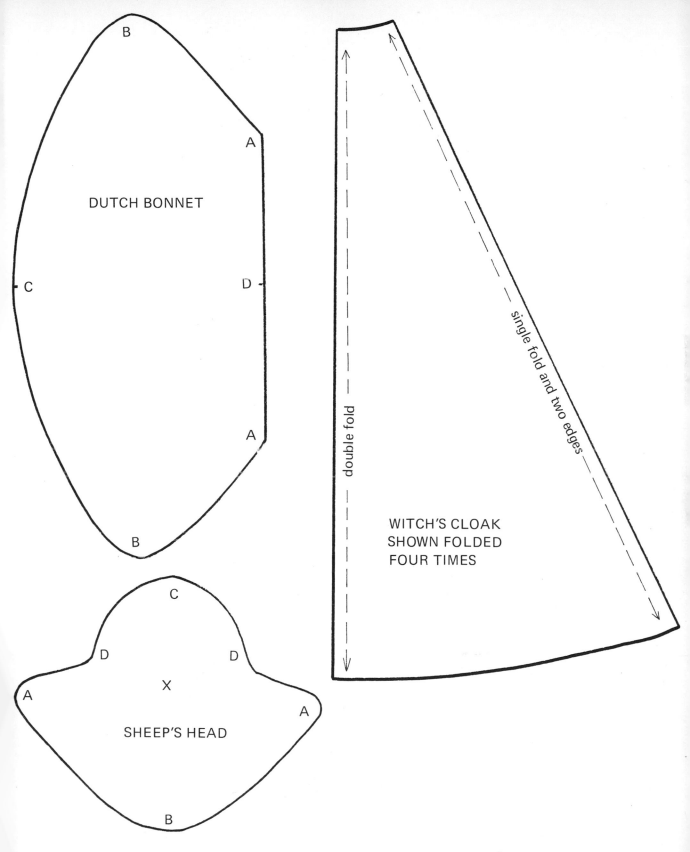

DUTCH BONNET

B

A

C

D

A

B

SHEEP'S HEAD

C

D

D

X

A

A

B

WITCH'S CLOAK
SHOWN FOLDED
FOUR TIMES

double fold

single fold and two edges

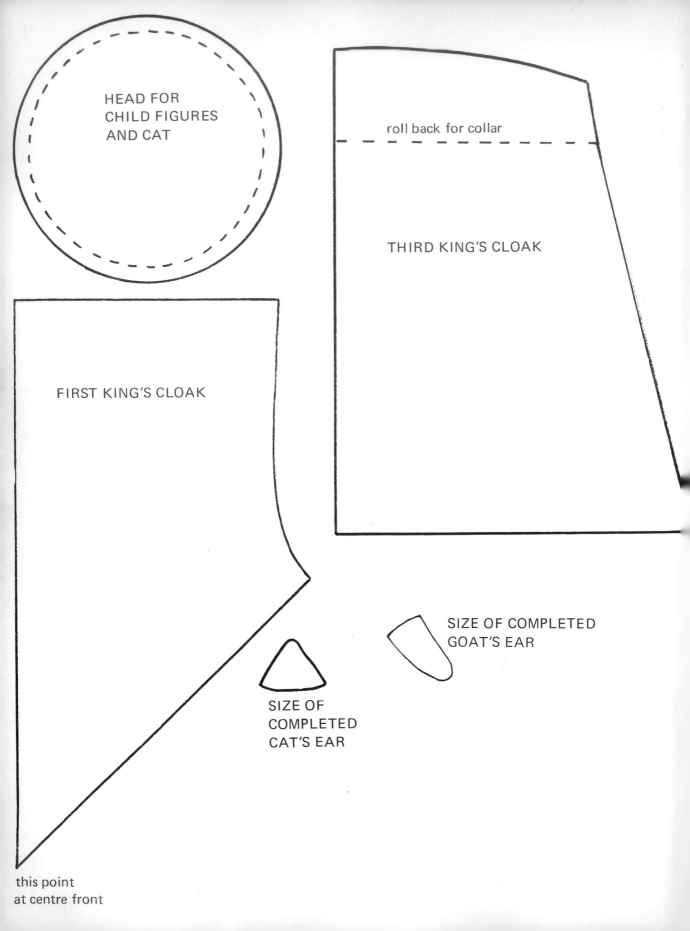

HEAD FOR
CHILD FIGURES
AND CAT

roll back for collar

THIRD KING'S CLOAK

FIRST KING'S CLOAK

SIZE OF
COMPLETED
CAT'S EAR

SIZE OF COMPLETED
GOAT'S EAR

this point
at centre front

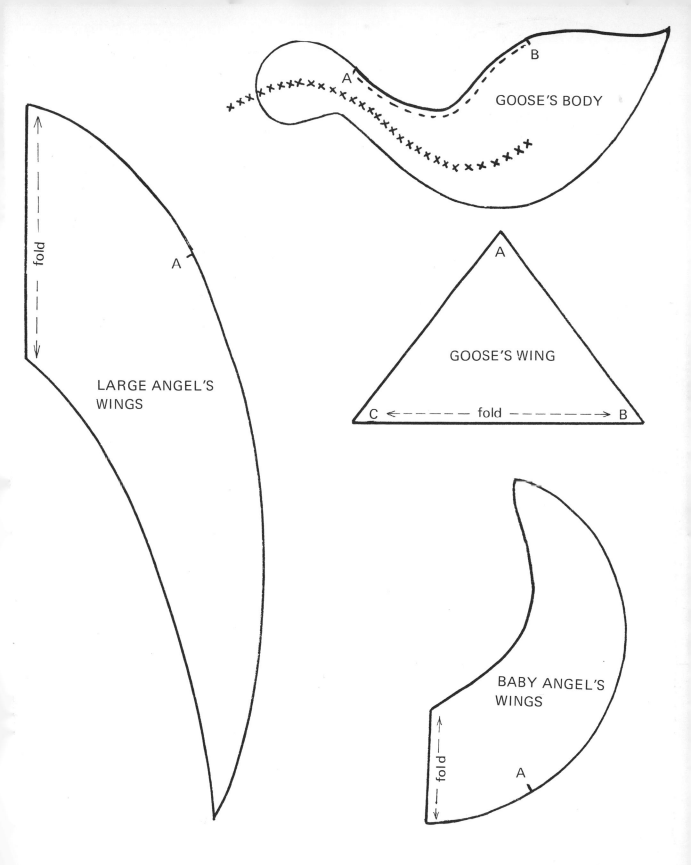

GOOSE'S BODY

B

A

fold

A

LARGE ANGEL'S
WINGS

A

GOOSE'S WING

C ← — — — — fold — — — — → B

BABY ANGEL'S
WINGS

fold

A

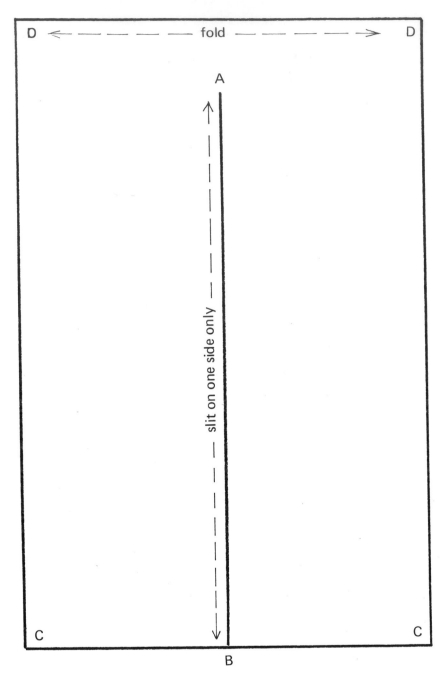

SHEPHERD'S SLEEVELESS COAT